IMAGES
of America

EARLY BALLARD

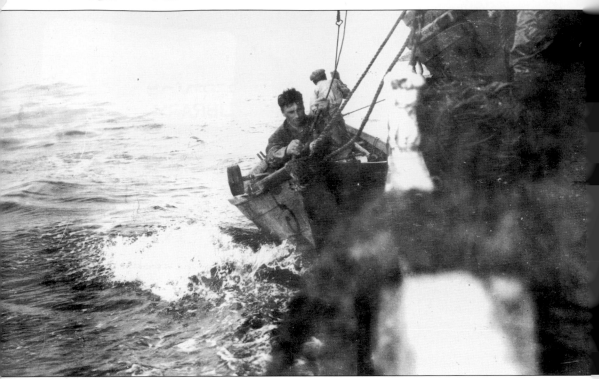

DORY FISHING. Ballard has always had a strong maritime industry, and this early photograph shows the *St. John* with John Linvog in the dory. Until the 1930s, fishing boats went out to the fishing grounds under power, but were required to fish under sail. When this was outlawed as too dangerous, lines were set from the decks of the schooners themselves. (Courtesy Nancy Linvog Ferkingstad.)

ON THE COVER: The first streetcar line to Seattle was built in 1890. By 1906, Ballard had lines from downtown, from Ballard to Fremont, and the interurban as far as Bitter Lake. Streetcars were the favored mode of transportation, since most people did not own cars. In the days before annexation to Seattle, Ballard had its own street naming system. Seventieth NW was Sloop Street, a name that, along with "Canoe St.," can still be seen on signs bordering Salmon Bay Park. The motorman on left is the author's grandfather Jack L. Pheasant. Note that the street is still unpaved. (Courtesy Bob Pheasant.)

IMAGES
of America

EARLY BALLARD

Julie D. Pheasant-Albright

ARCADIA
PUBLISHING

Published by Arcadia Publishing
Charleston, South Carolina

Printed in the United States of America

Library of Congress Catalog Card Number: 2007930839

For all general information contact Arcadia Publishing at:
Telephone 843-853-2070
Fax 843-853-0044
E-mail sales@arcadiapublishing.com
For customer service and orders:
Toll-Free 1-888-313-2665

Visit us on the Internet at www.arcadiapublishing.com

I would like to dedicate this book to my great-grandparents, who had the foresight to homestead in Washington; to my grandparents, who had the good fortune to settle in Ballard; and to my parents, Robert Preston Pheasant and Helen Johnson Pheasant, who had the great good sense to stay. I would also like to dedicate this book to the memory of the 677 men and women of the fishing fleet of Seattle who lost their lives in that most dangerous of occupations and who are memorialized at Fisherman's Terminal. Finally, I would like to honor some of those brave few—James "Foss" Foster and the crew of the Northwest Mariner, who lost their lives on January 15, 1995.

"They that go down to the sea in ships;
That do business in great waters;
These see the works of the Lord, and His wonders in the deep."
Psalms 107: 23–30

CONTENTS

Acknowledgments 6

Introduction 7

1. Natives, Homesteaders, and the West Coast Improvement
 Company 11

2. Police, Fire, and Transit 23

3. Locks and Bridges 33

4. Ballard Avenue and Beyond 45

5. Shingle Capital of the World 57

6. Shipbuilding, Fishing, and Messing About in Boats 65

7. Public Schools, Parochial Schools, and the Peanut College 79

8. Fraternal Organizations and Churches 93

9. From Pigsties to Parades, and from Cradle to Grave 111

ACKNOWLEDGMENTS

I would like to thank the following: Bob Jacobsen for his wonderful photographs and memories; Nancy Linvog Ferkingstad for her fabulous collection of photographs and memorabilia; the entire extended Heggem clan for their wonderful images; Margie Conover for her amazing stories and photographs; Jan Harrington of the Brygger family; Mark Christensen; Clinton White for his priceless 1905 *History of Ballard*; Dave Wolter; Jan Hartung; Laura McLeod; Pearletta Rasmussen; Bob Rutledge; Dru Butterfield at the Army Corps of Engineers; Ballard First Lutheran; Northminster Presbyterian; Paul Norlen; Amanda Holm; Ted Pedersen; Ann Donovan, Gloria Kruzner, and the staff at St. Al's; Margaret Anderson; Joyce Bailey; and Bertha Davis. I would also like to thank John Haram, Andy Highfill, Margo Bjornsson Highfill, Fred Hedman, Signe Heggem Davis, and John Davis for contributing images and an amazing amount of research.

I am eternally grateful to Rebecca Hildebrandt and Ann Wendell for all the heavy lifting they did in the production of this book in helping to sort through a gajillion photographs, and to Kat Richardson and Allan Albright for their technical wizardry. I would like to thank Prof. Jon Bridgman, Clint White, Sean Sheehan, Joann Pheasant, and Barry and Bud Hawley for their historical proofreading.

I would also like to thank the unsung heroes of history: Carolyn Marr, Nicolette Bromberg, Ann Frantelli, Eleanor Toewes, and Nancy Hines; this book would not have been possible without their kind assistance. I am especially grateful to my father, Robert Pheasant, for a lifetime of stories about Ballard, and to my mother, Helen Pheasant, for her support. To the young man who changed my tire one dark and stormy night on Highway 2, who told me that he was a fifth-generation Ballardite and begged me to tell readers that "we cannot afford to buy the houses that our grandparents and great-grandparents built by hand"—this project is for you, and all of us like you.

This book includes only a small sampling of the photographs of Ballard; another author, with another collection, might have told a different story. I wish I could thank the late Dode Bjork, Will Bjork, Gertrude Follman, Hildegarde Gjerde, Lorraine Bjork Hansen, Odd Johansson, Ole Heggem, and Mabel Morrison for telling me their stories and their parents' stories and for kindling my lifelong interest in Ballard's history.

INTRODUCTION

Ballard is a distinctive Seattle neighborhood with a definite Scandinavian flavor. It was a city in its own right between 1890 and 1907, and the handsome business district is on local and national historic registers. Many myths have arisen about Ballard, and in these pages I hope to put some of them to rest. Did Ballard become annexed to Seattle because of the water system? Was there a morgue in the Ballard Building? Is the building haunted? Was there really a Ballard city ordinance mandating a church built for every saloon?

The first claim in the city of Ballard was made in 1852, but not until a ferry captain named William Ballard lost a bet with a business partner and found himself the owner of 160 acres of seemingly worthless logged-off land did Ballard truly begin to flourish. The West Coast Improvement Company formed in 1897 and proceeded to undertake one of the most incredibly profitable land development schemes ever conceived. Incorporated in 1890, the new town grew quickly, thanks to shingle mills, lumber mills, and the Scandinavian fishing fleet. A beautiful town hall was erected in 1899, and the thriving business district on Ballard Avenue rose alongside.

Meanwhile, the city of Seattle suffered a raging firestorm on June 6, 1889, destroying 25 city blocks, including every wharf, warehouse, and mill between Union and Jackson Street when a glue pot tipped. Ballard mills supplied the lion's share of the lumber that would rebuild downtown Seattle, causing an unprecedented industrial boom.

In 1906, reluctant Ballardites voted to be annexed to the city. Seattle could not grow northward without annexing Ballard, and Ballard was facing a dire situation with its inadequate water supply. The *Seattle Times* even ran an advertisement promoting doing "anything" to annex Ballard, along with the other six suburbs of Seattle. The deciding factor in the vote was the discovery of a horse in the reservoir. Cynical Ballardites still believe that the horse did not commit suicide and that it did not end up there by accident.

The water from the wells behind Salmon Bay Park was being supplemented by water sold by the City of Seattle from the Cedar River watershed by 1902, but by 1906 Ballard's water supply was being held hostage by Seattle. After three successive no votes, annexation passed by 122 votes. On May 29, at 3:00 p.m., the fire bell at Ballard City Hall rang 22 times, the flag at city hall and the fire headquarters flew at half mast, and Ballard was made a part of Seattle.

In terms of industry, the output of its mills made Ballard the "Shingle Capital of the World." The city built a new port at Fisherman's Terminal for the fishing fleet, and in 1916, the Hiram Chittenden Locks connected Ballard with the ship canal, Lake Union, and Lake Washington. In 1923, the Eagles built the impressive Eagles Building on the corner of Market and Twenty-second at a cost of $425,000. In 1927, the author's grandfather, with three other members of the newly formed Ballard Commercial Club, sold 1,150 shares of stock at $10 each to build one of the first hospitals north of downtown Seattle: Ballard Accident and General Hospital. (The building is supposedly haunted.) The same men—J. L. Pheasant, Dwight Hawley, J. W. Harvey, and Charles Paul—would raise the unimaginable sum of $9,186 in one day in 1927 to advertise and promote the virtues of Ballard to the rest of the world. Little did they know that 80 years later, the Ballard of shingle mills and shipyards would become a faint memory.

Old-timers still know Ballard as "Snoose Junction" for the "snoose" that the Scandinavian fishermen and mill workers chewed. Although not the only ethnic groups, those of Norwegian, Swedish, Finnish, Icelandic, and Danish heritage were the most cohesive and noticeable. Between 1860 and 1880, eleven percent of Norway's population immigrated to America; Ballard drew them to a familiar landscape, industry, and sponsors. By 1920, some 24,000 Scandinavians were living in Seattle, many in Ballard. U.S. Census figures are skewed by the fact that many immigrated through Canada, as it was cheaper, closer, and easier to access. The second biggest immigrants to Seattle were "Canadians," largely made up of recent Scandinavian transplants! Norwegians and Swedes made up the bulk of the immigrants, and they brought their skills with them to the new country. Many were fishermen, and the beautiful and graceful fleet of halibut schooners built in Ballard boathouses was a credit to the skill and craftsmanship of the shipwrights. Most fishermen worked as carpenters, cabinetmakers, and shipbuilders in the winter months, and many of the beautiful Craftsman houses in Ballard are the proud product of their labor.

What made Ballard unique in many ways was its industry. A city within a city, it was a mill town, a fishing town, and a hardworking maritime center. Ballard has always been proud of its blue-collar roots and its industrious citizens. As the shingle mills disappeared, the log booms no longer made their way through the locks, and the mill houses were torn down to make way for industry and apartment buildings. As the Puget Sound fishery was fished out, Ballard fishermen traveled to Alaska in the summers to fish for halibut and salmon, and the crab fleet to the icy Bering Sea in the winter. One by one, the boathouses and dry docks disappeared, though the vast green bulk of the Pacific Fishermen still stands as a sentinel at the bottom of Twenty-fourth Avenue NW.

Legend states that Ballard's founding fathers wrote a mandate requiring the same number of churches as saloons within the city limits. Although an interesting anecdote, this is not true. Nevertheless, the rumor persisted, and a documentary was made on the subject by students at the University of Washington debunking the story. It has always been a coincidence that Ballard has had exactly the same number of bars and churches; however, in recent years a survey would show a preponderance of bars. Unlike many predominantly Scandinavian towns in the Midwest, Ballard's population was hard-drinking as well as churchgoing.

Ballard continues to retain the feeling of a small town, and many of its current residents are third-, fourth-, and fifth-generation Ballardites. The city's Scandinavian flavor is still evident in many ways: the last Norwegian newspaper in America, the *Western Viking*, started on May 17, 1889, is published here; delicacies are created in Scandinavian bakeries and shops; and Norwegian and Icelandic sweaters are worn on the streets. Up until the 1970s, enough schoolchildren spoke another language at home that they could confound the teachers at Ballard High School. One of the most overwhelming features of Ballard has always been the sense of community cohesiveness and fraternity, chiefly due to ties by blood, marriage, and heritage.

The old Ballard is rapidly being caught between gentrification and the disappearance of industry. Where the old mill workers' houses stood below Market Street is now largely industrial, and every day more homes are being torn down in lower Ballard to allow for canyons of condominiums and apartment buildings, to fulfill the city's need for "higher density housing." The old Daniel Webster Grade School has been converted to the Nordic Heritage Museum; the Ballard Firehouse, an upscale restaurant; the Elks Building, a health club; and the Eagles Building, a plethora of retail outlets. The Fentron Building currently houses shops, and gradually industry is being forced out. The Ballard Avenue of single-room apartments and hotels, seedy bars, pool halls, and hardware stores has become a hotbed of trendy boutiques and pubs.

The Belltownization of Ballard has real and serious impacts on the people who live and work here. The North Pacific Fishing Fleet, based in Ballard, typically accounts for between 30 and 40 percent of the *entire* American domestic fish harvest, and the marine industry in Ballard accounts for a good share of the $4 billion marine industry in Seattle. Retail and service businesses do not bring the same income into the neighborhood that industry has—and still does. The Ballard Interbay Northend Manufacturing Industrial Center (BINMIC) is all that stands between industry and the complete surrender of Ballard to developers. With the advent of more condominiums, less

affordable housing, and parking headaches, the city is in danger of losing the singular identity that made it attractive in the first place.

The old shingle mills are now the site of restaurants, marinas, and storage warehouses. In a town where most people lived where they worked, Ballard is rapidly becoming a community of carpetbaggers and commuters. More than 100 years after the first land boom in Ballard, another land boom is making affordable housing a faint but fond memory, and retail is rapidly replacing industry. Only time will tell what the future holds.

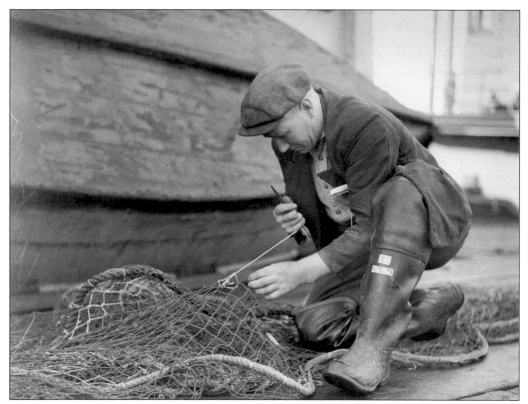

BALLARD FISHERMAN MENDS NET AROUND 1900. Fishing nets were made with a lead line at the bottom and a cork line at the top. Ballard still retains its maritime heritage, and the North Pacific fishing fleet out of Ballard counts for approximately 40 percent of all fish caught in the United States. (Courtesy Swedish Hospital.)

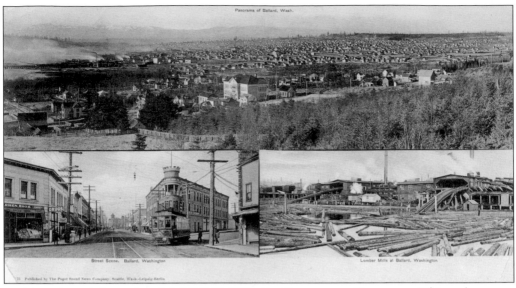

PANORAMIC POSTCARD. This early postcard shows what was important to Ballard: the mills, the new city hall, the waterfront, and the schools. (Courtesy author's collection.)

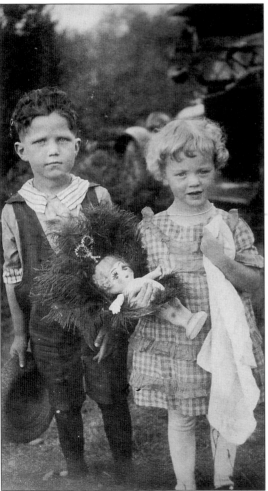

BALLARD CHILDREN. Bob Pheasant and Corrine Collins stand in Ballard in 1922 at the spot where the Ballard Building stands today. Note the kewpie doll Corrine is holding.

One

NATIVES, HOMESTEADERS, AND THE WEST COAST IMPROVEMENT COMPANY

Ballard's first white settlers were Osborn Hall and Ira W. Utter, who homesteaded here in 1852, but it had long been the home of the Shilshole band of the Duwamish tribe. By 1865, all the prime land along Salmon Bay was homesteaded, and by 1870, about 100 people had settled along the bay. On June 20, 1882, Judge Thomas Burke bought 720 acres of Utter's homestead and platted it into 10-acre tracts called the Farmdale Homestead. His original plan was to sell the lots to farmers to provide fruit and vegetables for the residents of Seattle. Simultaneously, Captain Ballard would win 160 acres of land adjoining Gilman Park in a coin toss. (Ballard had been captain of his brother's steamboat, the *Zephyr*, thus acquiring the title.)

In 1888, the Lakeshore and Eastern Railroad connected Seattle and Ballard. Railroad promoter D. H. Gilman owned land at Smith Cove and advertised that the railroad machine shops would be built there, causing a small land boom. At the same time, Captain Ballard and John Leary bought 642 acres of land. Judge Burke gave up the Farmdale idea and joined the two men to form the West Coast Improvement Company, platting the present site of Gilman Park in December 1888. The company, formed in 1887, consisted of a combination of Seattle interests and Salmon Bay pioneers, including the Ballards, Burkes, Learys, Crawfords, Hamblets, Dennys, and Dexter Horton. Adding to the original 720 acres and dividing them into 3,000 lots, the West Coast Improvement Company would realize one of the greatest real estate success stories on the Pacific Coast. Lots on Ballard Avenue that sold for $5 in 1887 would sell for $1,800 in 1890; it is said that Captain Ballard saw a 300 percent profit on his land. A plot of land in Ballard forms from the convergence of streets named for the men instrumental in the company: Ballard, Burke, Tallman, Leary, Russell, and Barnes.

By 1905, Ballard had electric lights, a good water system, two weekly papers, a sewage system, a police force, a hospital, a telephone system (with free long distance to Seattle), two telegraph systems, laundries, dairies, 12 mills, mill yards, shipyards, dry docks, a fire department, two streetcar lines, and about 10,000 inhabitants. By the time of annexation in 1907, Ballard was the seventh largest city in Washington.

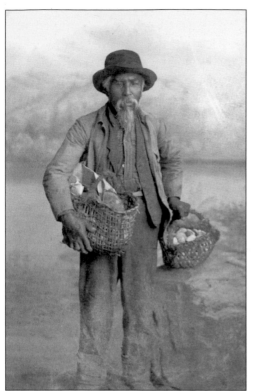

SHILSHOLE CHARLIE. The first settlers of Ballard were the Shilshole-amish, (alternately Shul-shales), a band of the Duwamish tribe. The word *Shilshole* comes from the word *cilcole*, meaning "to thread a needle," referring to canoe travel up from Salmon Bay. By the time the first white settler, Ira Utter, arrived in 1862 at the backwater of Salmon Bay, only about 12 families were left, led by Salmon Bay Curley. Early settlers coexisted peacefully with the Shilshole people, who lived on both sides of Salmon Bay. By 1890, all the land below Sixty-fifth Street had been cleared, and the native people had to travel farther north to gather food and wood. The last 20 or so Shilsholes living in Ballard were relocated to reservations when the locks were built in 1914. Shilshole Charlie, seen here, was a familiar sight in Ballard. (Courtesy Swedish Hospital.)

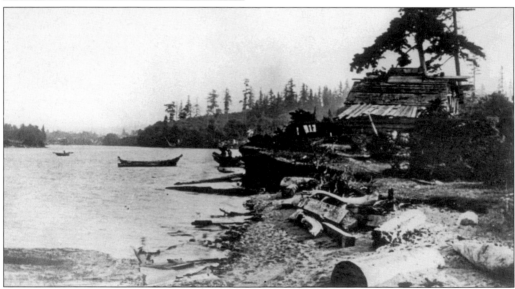

CABIN OF SHILSHOLE CHARLIE. Shilshole Charlie and his wife, Madeline (Chilohleet;sa), the last of the Shilshole band of the Duwamish tribe in Ballard, made a living selling clams, fish, and berries to local residents and resisted being moved to the Port Madison reservation. After Madeline died around 1914, Shilshole Charlie was taken away to a reservation and his cabin burned. The cabin sat on a knoll near the foot of what was later developed as Sheridan Street in Magnolia. This image shows Shilshole Charlie's cabin on the south side of Salmon Bay about 1902. (Courtesy John Haram.)

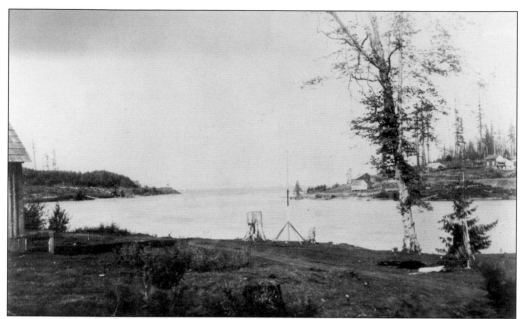

VIEW OF BALLARD FROM MAGNOLIA. In this, one of the earliest images of Ballard, houses and farms are seen in the foreground while forests stretch away into the background. This photograph was taken about 1889, when Ballard was known as Gilman Park. It became colloquially known as Ballard's when streetcar passengers asked to be dropped off at "Ballard's place" instead of Gilman Park, and the name stuck. (Courtesy Swedish Hospital.)

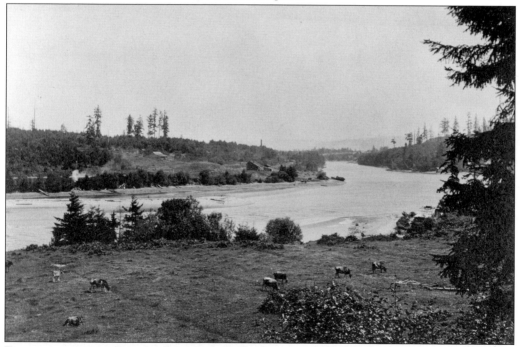

BALLARD AROUND SALMON BAY. Early Ballardites found Salmon Bay a protected harbor, but too shallow at low tide to bring large ships very far inland. Note the cattle grazing along the waterfront. (Courtesy Swedish Hospital.)

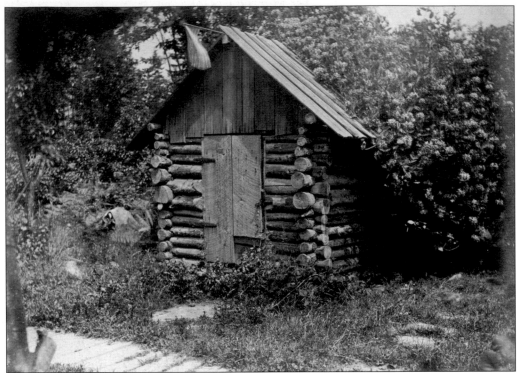

ROSE-COVERED CABIN, BALLARD, C. 1900. This image was similar to one included in a 1905 *History of Ballard*, which claims the pictured structure was the first actual building constructed by white settlers in what is now Ballard. The little log cabin, on Shilshole between Second and Jefferson, was owned by Charles Hadfield. (Courtesy author's collection.)

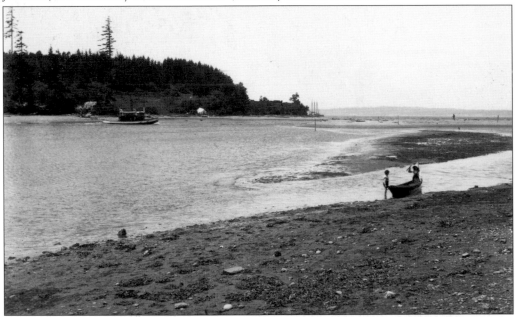

MOUTH OF SALMON BAY. Salmon Bay is shown here before the locks were built. Note the tent on the Magnolia side and the three-masted schooner in the distance. (Courtesy John Haram.)

HENRY WHITNEY TREAT. Henry Treat, a mover and shaker of early Ballard, named Golden Gardens for his daughter Golden and Loyal Heights for his daughter Loyal. Until Seaview Avenue was pushed through in the 1930s, the only way to Golden Gardens was by cable car, horse, or a windy gravel road from Eighty-fifth Street. Treat began the Loyal streetcar line as a way to promote his real estate, and he built an amusement park at Golden Gardens to attract prospective buyers. (Courtesy Museum of History and Industry [MOHAI].)

HENRY TREAT'S HORSES. Henry Treat is pictured in Ballard with his horses. (Courtesy MOHAI.)

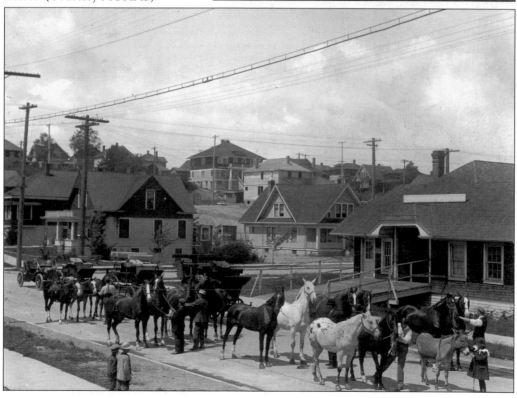

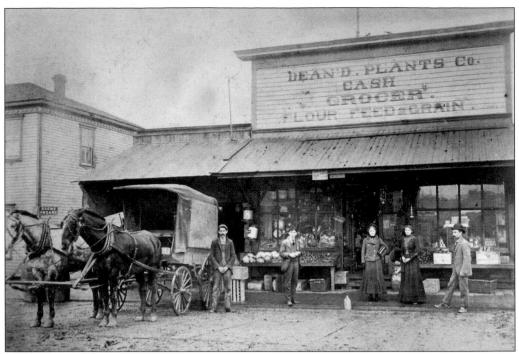

CASH GROCERY. Dean Plant's Cash Grocery was one of the earliest businesses in Ballard. Emma and Dean Plant stand at the end of a line on Leary in 1888. (Courtesy Swedish Hospital.)

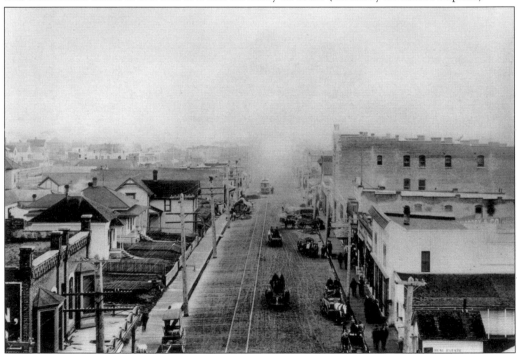

BALLARD AVENUE, 1901. This view, looking southeast, shows tracks and a streetcar in the distance. Note the wooden sidewalks and the residential nature of Ballard Avenue. (Courtesy author's collection.)

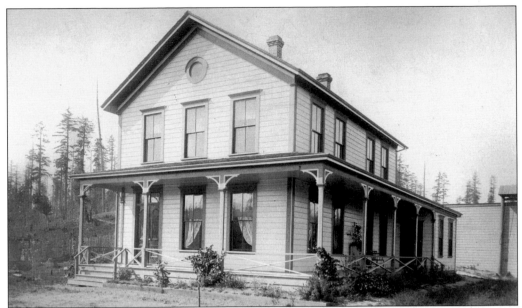

BRYGGER'S HOUSE ON THIRTY-SECOND AND MARKET. Started in 1882 and completed in 1886, this structure was the original home of the Bryggers, early Ballard settlers. Johan Brygger came from Stavanger, Norway, and set up a salmon-salting operation on Salmon Bay in 1876. He and his wife, Anna, had eight children: Albert (reportedly the first white child born in Ballard), Ethel (who married Joshua Green), Barbara, James, Annie, Jennie, John, and Thrina. Annie and Jennie lived in the homestead their entire lives. The Bryggers donated what would become the first real schoolhouse in Ballard, and Anna served as the school district clerk. She later owned large tracts of land on Magnolia. (Courtesy Jan Harrington.)

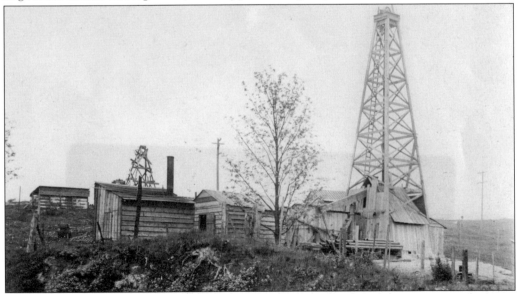

BRYGGER'S OIL WELL AT THIRTY-SECOND AND FIFTY-FOURTH. Sadly, no oil was really found at this Sunset Hill location. The Bryggers were one of the most influential families in Ballard, and yet the only remaining sign of their authority is a street sign on an alley near Adams School. One of their homes was moved and remodeled into what is now the Lockspot. (Courtesy Jan Harrington.)

EARLY BALLARD STORES. Late-19th-century shops included Kastners, Peterson Hardware and Plumbing, the New Store, Jacobsens, M. A. Ross Groceries, Cascade Drug Company (Ballard Station), LaChall, the Hatter, Knosher's Dry Goods, Sealship Oysters, Schram Hardware, Pop Smith's Candy ("Fresh Daily!"), Jos. Mayer and Brothers Jewelers, and other stores of virtually every description.

MALM HOUSE. Sisters Christina and Maria "Mary" Jansson emigrated from Varmland, Sweden, in 1883. Christina married Andrew Malm (Malmquist) in Seattle in 1891. The two sisters constructed three houses and a grocery store in Ballard on Fourteenth Avenue NW (Railroad); these have recently been torn down to build townhouses. (Courtesy Dave Wolter.)

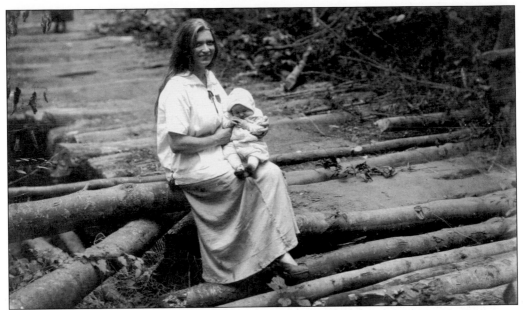

OLGA LINVOG. Olga Askelund Linvog came to Ballard in 1910 from a farm outside Stavanger, Norway. Olga is seen here with her son Earl on what appears to be either a log road or timber ready to skid to the mill. Her first job was with a Swedish couple who lived on Capital Hill, doing housework and taking care of their little girl who was ill. Olga took the streetcar to work from Ballard to Elliot Avenue, where the tracks were elevated along a stretch of snow-white beach. (Courtesy Nancy Ferkingstad.)

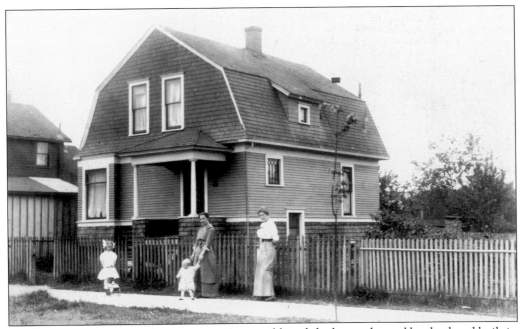

LINVOG HOUSE. Olga lived to be over 100 years old, and the house she and her husband built in Sunset Hill eventually sold for $500,000. (Courtesy Nancy Ferkingstad.)

SODERLUND HOUSE. The Soderlund family moved into the residence at 7043 Sixteenth Avenue NW in the spring of 1907, just four years after the home was built, having traveled from Wisconsin for the moderate climate. Pictured from left to right are Anna, John, Ben, daughter Anna (who died young), Alma, and Selma holding Verner (who also died as a child). At the time, the small structure was home to seven children, their parents, and the family matriarch (not shown), totaling three generations. The house was expanded in the 1920s to include indoor plumbing, and the original barn on the site was not razed until 1993. The property still includes a few of the original fruit trees. This image shows the current owner's great-grandmother and grandfather Ben. (Courtesy Laura McLeod.)

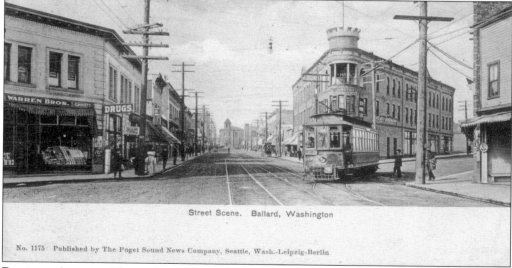

Street Scene. Ballard, Washington

No. 1175 Published by The Puget Sound News Company, Seattle, Wash.-Leipzig-Berlin

BALLARD AVENUE. This early postcard of Ballard Avenue shows city hall in the distance. The streetcar junction connected on Twentieth Avenue and Ballard Avenue to the interurban as well as the line to downtown Seattle. (Courtesy Clinton White.)

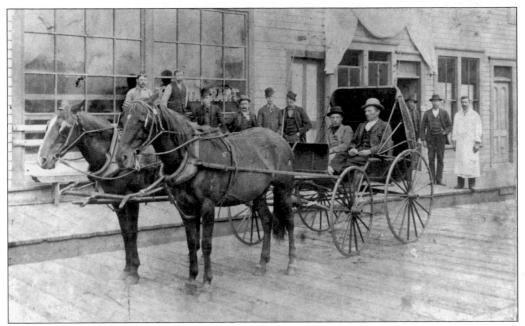

BALLARD AVENUE. The planked streets and sidewalks are clearly displayed in this early image of Ballard Avenue. (Courtesy Swedish Hospital.)

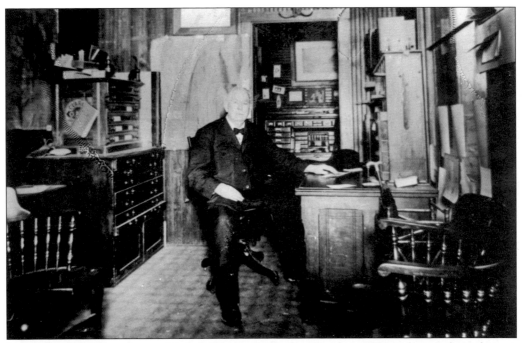

JUDGE VERNON. Seen here at his desk, Vernon arrived in Seattle in 1880 and opened a real estate office in Ballard. Vernon Street is named for him; contrary to popular belief, he never served as mayor. (Courtesy University of Washington.)

LEARY AVENUE. This photograph of a house at 4925 Leary Avenue was taken on September 14, 1910, when the road was mainly residential. Note the buggy at the side of the house. (Courtesy University of Washington.)

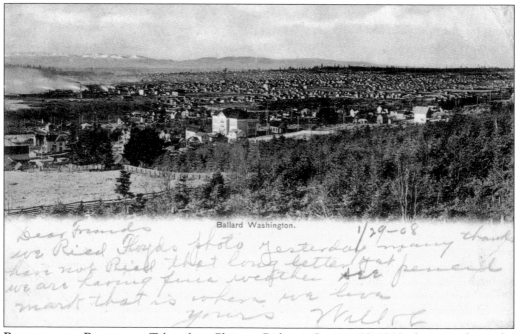

PHOTOGRAPH POSTCARD. Taken from Phinney Ridge on January 29, 1908, this view shows the Salmon Bay School as well as the mills in production. (Courtesy Laura McLeod.)

Two

POLICE, FIRE, AND TRANSIT

Until annexation with Seattle, Ballard had its own mayor, city council, and fire and police departments. Order in Ballard was first maintained by a town marshal, Mr. Van Meer, who was replaced in 1906 by police chief George Stratton. Lawlessness generally took the form of drinking, carousing, truancy, and gambling. Destitution did not absolve one of paying a fine; miscreants had to reduce their debts by working on the roads. In 1905, the newspaper reported that gypsy camps on Railroad Avenue (Fourteenth Avenue NW) presented a problem, proving that in 100 years, little has changed in Ballard in some ways.

Ballard was home to two private streetcar lines by 1900, and when the City of Seattle decided to form a municipal rail system, four miles of track were laid from downtown to Ballard. The very last streetcar in Seattle, in fact, ran down Eighth Avenue until 1941. The city actually cut through the backyards on Eighth Avenue NW to lay the streetcar lines, and even today one may notice that many of the houses that face Eighth NW show what are actually back porches.

The overwhelming reason that Ballard succumbed to pressure from the City of Seattle to incorporate was an inadequate water supply. Originally, streams flowed through Ballard down what would become its streets. Three artesian wells were sunk behind Salmon Bay Park, and a pump station on Fourteenth Avenue NW and Forty-fifth Street provided Ballard with its water supply. An analysis by the Washington State Board of Health proclaimed, "This water is bad. It contains a large amount of decomposing Organic mater in solution. If the water must be used for Potable purposes, it must be thoroughly boiled before each use."

Shortly before the vote to incorporate in November 1906, local lore says that a dead horse was found in the reservoir. However, a history of Ballard written in 1904, less than 15 years after incorporation as a city, states time and again that "now we get pure, clean water from the Cedar River." An interesting legal document shows that Seattle did in fact sell its water to Ballard up to 1906, but a lawsuit filed on July 19, 1906, cut off Ballard, putting pressure on the citizenry to vote for annexation.

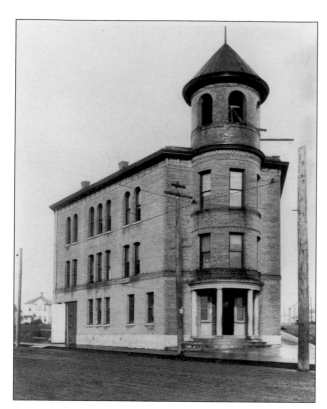

CITY HALL. Ballard City Hall, seen about 1902, housed the mayor's office, the fire and police departments, and the jail. The building was torn down in 1967 due to earthquake damage. The small park of Marvin's Gardens now stands on the spot and includes the original pillars. Marvin Sjoberg was a Ballard character in the 1930s through the 1970s who fancied himself the mayor. (Courtesy author's collection.)

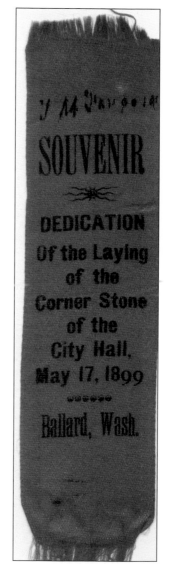

SOUVENIR

DEDICATION
Of the Laying
of the
Corner Stone
of the
City Hall,
May 17, 1899

Ballard, Wash.

SOUVENIR RIBBON. This ribbon commemorates the laying of the cornerstone of Ballard City Hall on May 17, 1899. One of the stone's signers was R. L. Hawley, grandfather of Bud and Barry Hawley. When the building was torn down, the cornerstone was lost. (Courtesy Clinton White.)

BALLARD POLICE DEPARTMENT. The man standing in the center is chief of police George Stratton; the mounted policeman on the right is Roy Presko. (Courtesy Pearletta Rasmussen.)

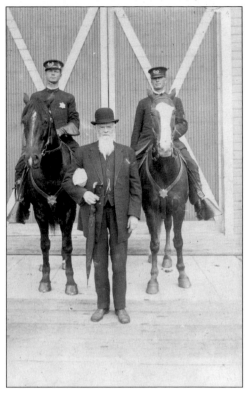

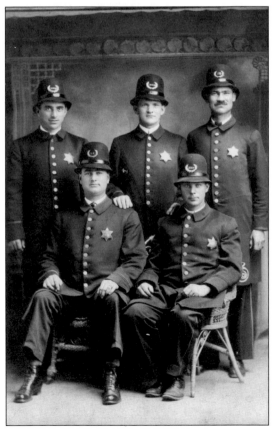

THE LONG ARM OF THE LAW. Crime in Ballard mainly involved drunk and disorderly behavior on Ballard Avenue, fights, and gambling. Taken inside the old Ballard City Hall, this photograph shows policemen J. Lawrence (seated, right) and Jakob Bjarnason (standing, right). (Courtesy Pearletta Rasmussen.)

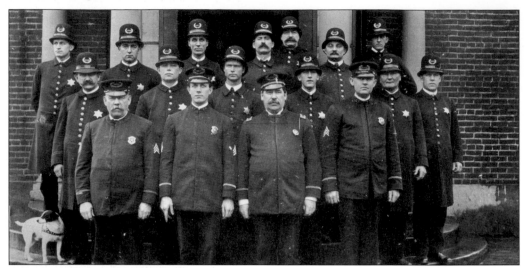

BALLARD POLICEMEN. Roy Presko (second row, third from the left) poses with his colleagues on the steps of city hall. Note the dog on the left. A letter written to city attorney Anthony Zook and Mayor J. W. Peterson complained that one of the major problems with gambling in Ballard was that the mayor owned one of the most notorious dens of iniquity: the White Front Saloon. "If you visit the White Front Saloon, run by Mayor Peterson," it stated, "you will find one of the worst dens this side of hell, and not fit to run, not even in Tacoma. . . . Visit the White Front or . . . the Brunswick, the Ballard Bar and see if you don't find gambling in all its forms." (Courtesy Pearletta Rasmussen.)

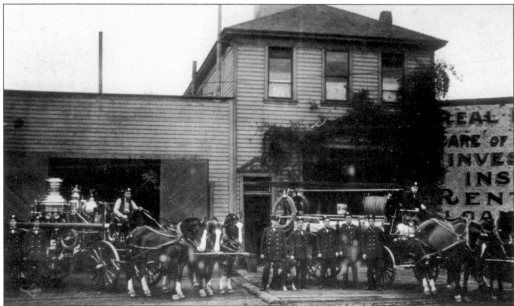

BALLARD FIREHOUSE, 1909. Two horse-drawn wagons sit in front of the Ballard Firehouse in 1909. The firehouse was moved to Seventeenth Avenue NW in 1911 and used as storage for many years. Until 1924, the fire equipment was drawn by horses, and until the 1960s, the stalls could be seen. The firehouse had dogs in the early years, and small children would run after the horses to see where the fire was. The dogs were important to protect the horses from curious onlookers. (Courtesy Rich Schneider.)

MILL FIRE. Fire was a singular hazard in Ballard, as the embers from the refuse burners at the mills presented a constant danger and most structures were wooden. The first fire department in Ballard consisted of volunteers; in fact, all the mill workers were considered "volunteer firemen." A fire in 1902 at Kellogg's Mill quickly spread to Stimson's, and both mills became total losses; insurance paid less than half. Because of an inadequate freshwater supply in Ballard, enterprising residents set up a system of saltwater fire mains. This fire occurred at a mill in 1910. (Courtesy Rich Schneider.)

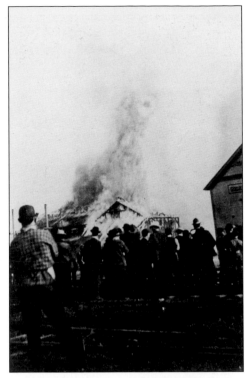

STATION NO. 18. Built at 5428 Russell Avenue NW in 1911, this building featured vertical steel beams connecting to a single wood beam. This combination of beams and wood cross members supported the second story without using posts, allowing for a large, unobstructed apparatus floor. The Ballard Firehouse was the oldest active station in Seattle when it was replaced by a modern building on Market near Fifteenth. (Courtesy Seattle Fire Department.)

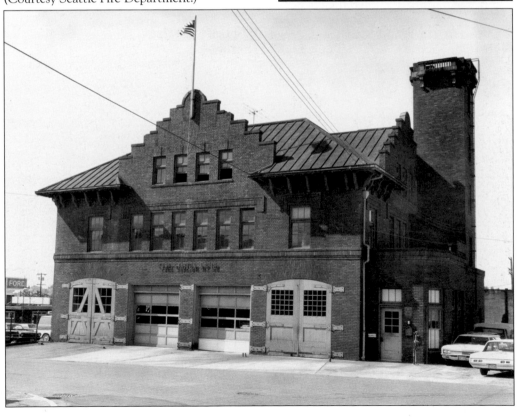

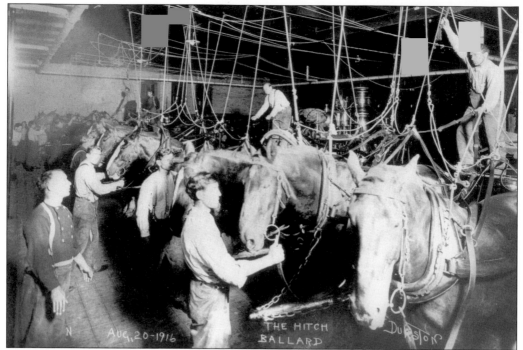

THE HITCH. In this 1916 photograph of the Ballard Firehouse, the team of horses is being hitched. According to witnesses, when the fire bell sounded, the harnesses would drop from the ceiling and the horses would walk into them. One of the original blocks can still be seen on the ceiling. The inscription on this photograph states, "New Way of Dept." No wooden support beams are visible in this room. (Courtesy Seattle Fire Department.)

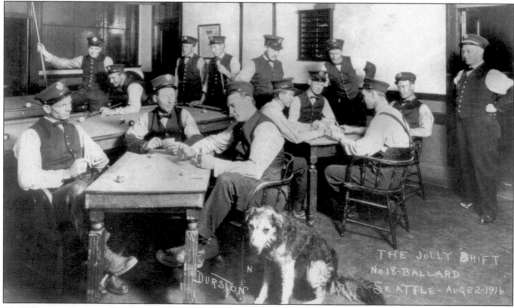

THE JOLLY CREW. On August 22, 1916, the "Jolly Shift" firemen play pool and cards upstairs, waiting for the alarm. Burns the dog sits nearby. The department also owned a cat, an animal most families kept around barns or livery stables to deter mice. (Courtesy Seattle Fire Department.)

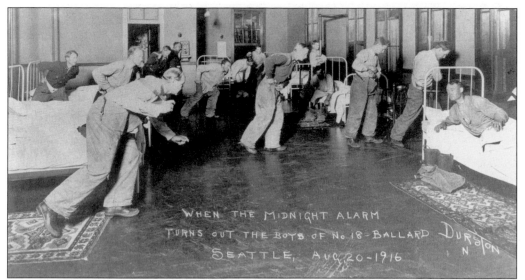

THE ALARM. The caption reads, "When the midnight alarm turns out the boys at No. 18 Ballard, Seattle, Aug. 20, 1916." The pole is still visible in the restaurant currently occupying the old Ballard Firehouse, though it has been cut off a third of the way down. (Courtesy Seattle Fire Department.)

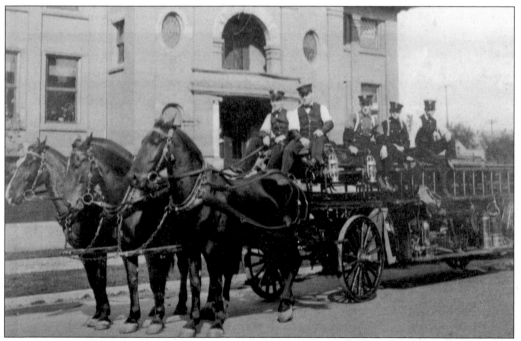

BALLARD FIRE DEPARTMENT AND CARNEGIE LIBRARY. The Carnegie Free Library was built in 1904 at a cost of $17,610. Ballardites raised $5,000 to purchase the property, and Carnegie gave a grant of $15,000. The grant did not apply to books, however, so the children of Ballard brought books to furnish the new library and raised money to provide more. This photograph, taken during the early part of the 20th century, perfectly exemplifies Ballard. Both the Carnegie Library and the firehouse are still standing, though repurposed as restaurants. (Courtesy Seattle Fire Department.)

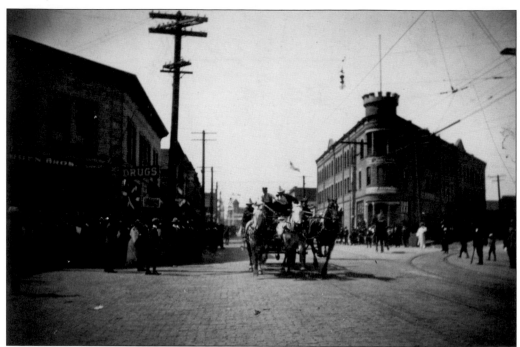

FIRE! A fire wagon responds to an alarm in 1910, turning down Ballard Avenue from Twentieth Avenue, with the flag flying at city hall in the background. (Courtesy University of Washington.)

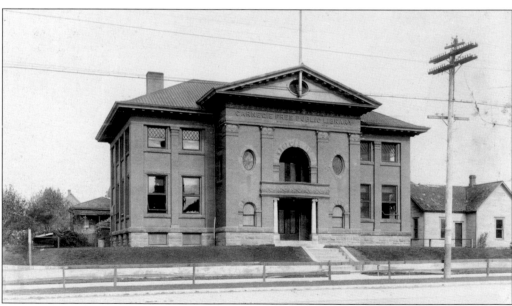

CARNEGIE LIBRARY. This library was used until a new facility was built at Fifty-eighth and Twenty-fourth Avenues in the 1960s; the newer building is now due to be demolished. The children's wing occupied the third floor. Designed by Henderson Ryan, the front entry is made of stone quarried near Black Diamond; the brick came from a yard near Spokane Street on Beacon Hill. The distinctive balcony is composed of convex sheet metal. The old library is now home to Carnegie's, a wonderful French restaurant. (Courtesy University of Washington.)

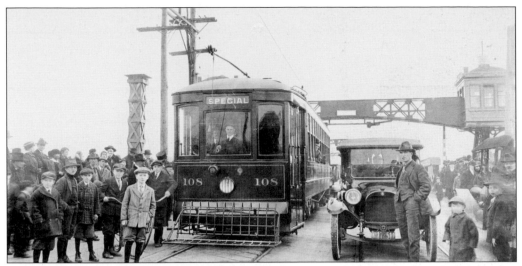

MUNICIPAL STREET RAILWAY. These images depict the formal opening of the Municipal Street Railway on January 27, 1918, from Seattle to Ballard. On May 23, 1914, four miles of track were completed from the intersection of Third Avenue and Pine Street downtown north to the edge of Ballard at Fourteenth Avenue NW. The tracks had to be rerouted with the opening of the locks and the Fifteenth Street Bridge. In 1918, the Loyal Railway Company, which serviced the Ballard area and Loyal Heights, was incorporated into the Division A line. Note the Majestic Theater in the background. (Courtesy Seattle Municipal Archives.)

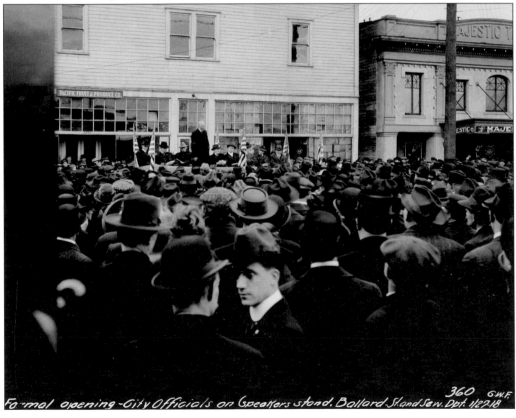

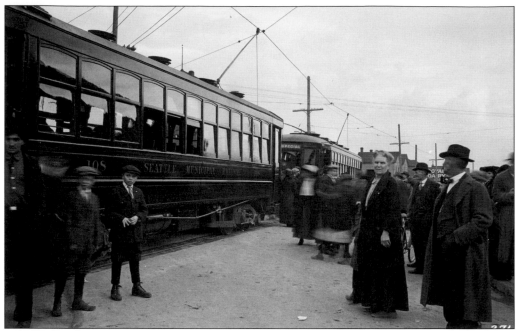

SEATTLE MUNICIPAL STREET RAILWAY. Here is an additional view of the Seattle Municipal Railway's formal opening in 1918. The Royal Dairy horse-drawn cart appears in the background. This was by no means the first street railway or trolley in Ballard. Early trolleys were pulled along tracks by horses, thus the nickname "hayburners." Stone and Webster were operating 22 streetcar lines in the Seattle area by 1889. Fred Sander began an interurban railway line in 1900, but it would take him six years to lay six miles of track to Haller Lake. (Courtesy Seattle Municipal Archives.)

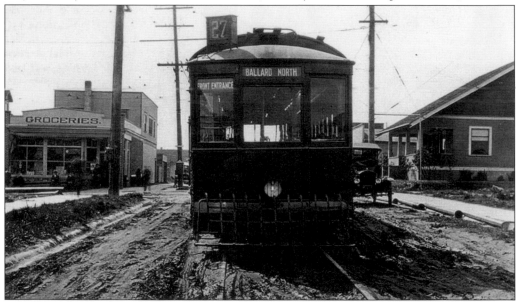

BALLARD STREETCAR. The Ballard North line, which traveled up to Phinney Ridge, was completed in 1911. Generations of Ballardites took the streetcar to Green Lake for swimming in the summer and ice-skating in the winter. In addition, "the Dinky" ran from Market Street up Twentieth Avenue to Salmon Bay Park on Sixty-seventh. (Courtesy Ted Pedersen.)

Three

LOCKS AND BRIDGES

The biggest civic projects in Ballard involved bridges and locks. The city's first bridge was a wooden structure built across Salmon Bay at Fourteenth Avenue NW in 1889 by the West Coast Improvement Company. It was a wagon bridge made of puncheon (split logs with the faces smoothed). Raising and lowering with the tides, the span served for a couple of decades before it rotted. The next bridge was also constructed at Fourteenth Avenue NW, along with the railroad bridge.

Until the building of the locks, the outlet of Lake Union at Fremont was far too small to allow ship traffic. Started in 1911 and completed in 1916, the Hiram Chittenden locks allowed large ships to pass from Ballard into Lake Washington. Salmon Bay and Shilshole Bay were navigable at high tide, but essentially dry at low tide. Built at a cost of almost $4 million, the locks and ship canal remain one of the most ambitious engineering enterprises of all time, and are among the largest and busiest locks in the world.

Much controversy ensued over the placement of the locks. In 1910, more than 1,300 property owners on Salmon Bay petitioned the secretary of war to have the locks built at their present site; the mill owners wanted the locks built farther upstream. This was because the locks raised the water level 14 feet and dropped the level of Lake Washington to the level of Lake Union, flooding many mills and shipyards.

Road grading was another ongoing municipal project. The first roads in Ballard were basically cow paths winding through the timber and following the paths of logging roads. The unpaved muddy roads were replaced by wooden roads, which were uneven, slippery, filthy, dangerous, and subject to rotting.

SALMON BAY BEFORE DREDGING. With the building of the locks, many boathouses, shipyards, and mills were condemned by the City of Seattle and flooded. (Courtesy Margaret Anderson.)

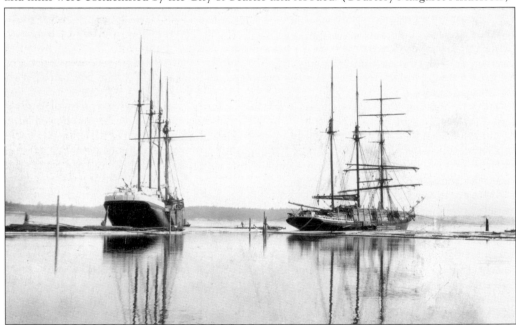

TALL-MASTED SHIPS ON SALMON BAY. Before the dredging of the ship canal, Salmon Bay was too shallow to allow most large ships to dock, although many were built here and returned for repairs. Capt. Fred Anderson ran a tug and transport service out of Anderson's Boathouse to ferry people between the ships and shore. This view of a lumber schooner and a barkentine was taken around 1910 in Salmon Bay. Men can be seen on the log booms between the ships. (Courtesy Margaret Anderson.)

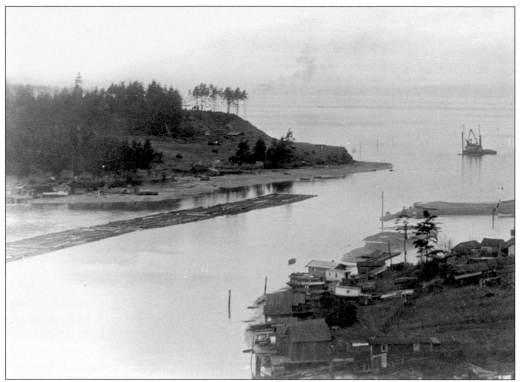

SALMON BAY. This March 1, 1915, view provides a clear depiction of early Salmon Bay prior to the completion of the locks and railroad bridge. Notice the log boom in the background. (Courtesy Army Corps of Engineers.)

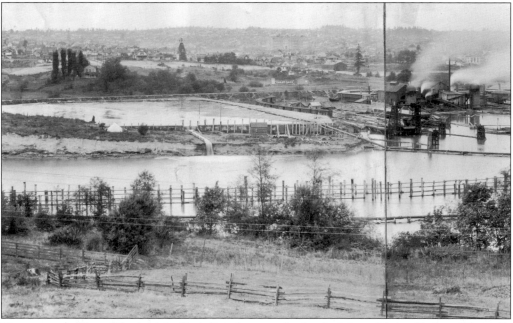

TERRITORIAL VIEW. The initial pilings have been set for the dredging of the cofferdam. The mills and shipyards of Ballard occupy the distance. (Courtesy Army Corps of Engineers.)

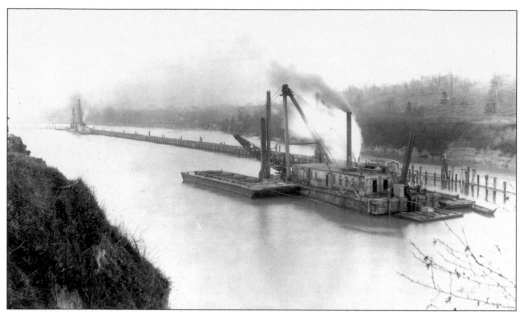

EXCAVATION. The construction of the locks commenced on August 6, 1911. This image was taken in February 1912 at the beginning of the excavation process. Seen are two floating dredges prior to the completion of the cofferdam. (Courtesy Army Corps of Engineers.)

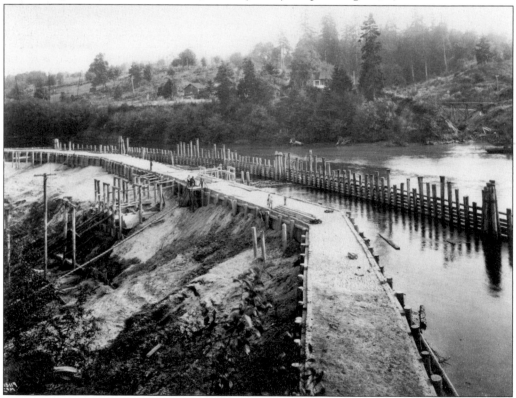

LOCKS, OCTOBER 1912. This wide-angle shot provides a view of the excavation inside the cofferdam. To the left are several men with a soil tester. (Courtesy Army Corps of Engineers.)

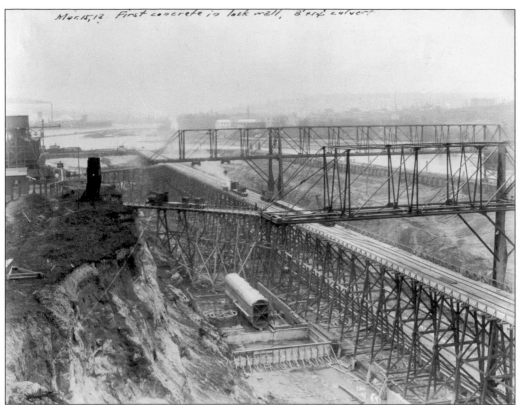

March 15, 13 First concrete in lock wall, 8'x14' culvert

LOCKS, MARCH 15, 1913. The first concrete block has been placed in the wall, along with the first culvert. The 24 culverts in the upper chamber and 28 in the lower are 8.5 feet wide and 14 feet tall and control the flow of water into the locks. (Courtesy Army Corps of Engineers.)

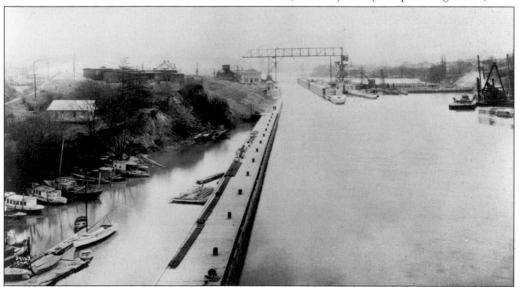

LOCKS NEARING COMPLETION. This view looks east from the Great Northern Railroad Bridge at Salmon Bay. The distinctive Army Corps of Engineers Building can be seen in the distance. (Courtesy Army Corps of Engineers.)

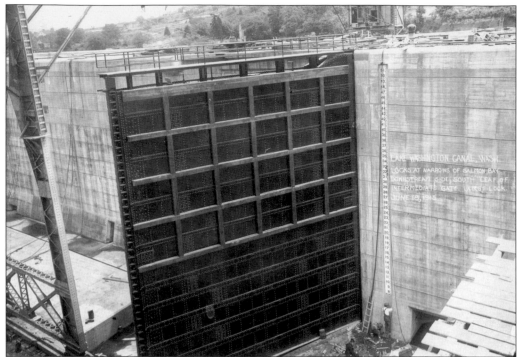

LARGE LOCKS. The man at the bottom of this large lock provides an idea of scale. The lock walls rise 64 feet above the foundation and 55 feet above the floor. (Courtesy Army Corps of Engineers.)

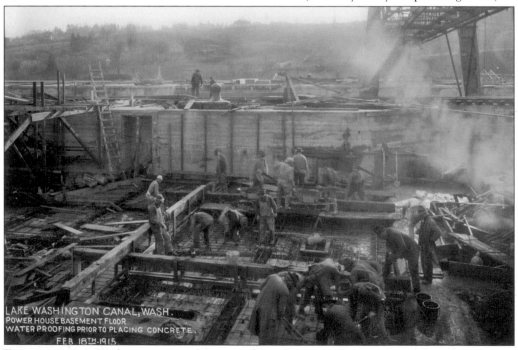

FEBRUARY 1915. Workers waterproof the powerhouse basement floor prior to placing the concrete. Over 227,000 cubic yards of concrete were poured in both locks and the dam. (Courtesy Army Corps of Engineers.)

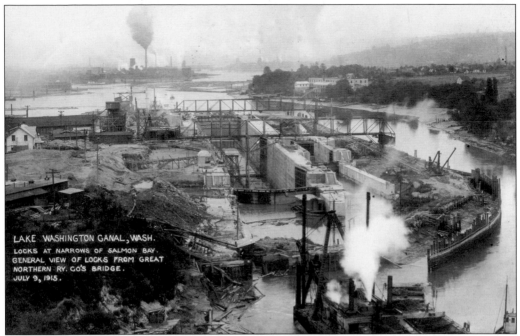

LOCKS, JULY 9, 1913. This view of the narrows at Salmon Bay looks east from the railroad bridge. The small lock was opened on July 30, 1916, and the large lock on August 3, 1916. (Courtesy Army Corps of Engineers.)

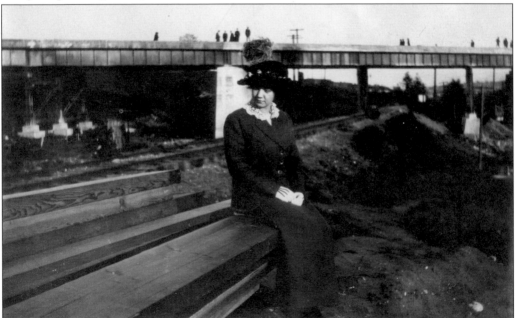

RAILROAD BRIDGE. Once the locks were built, the railroad bridge had to be changed to a bascule bridge to allow ships to travel beneath it. This ingenious structure relies on a huge concrete counterweight to keep the span open. The Fifteenth Street Ballard Bridge also had to be constructed as a drawbridge. Here Ethel Preston sits on a pile of railroad ties; notice the men on the bridge above. (Courtesy Bob Pheasant.)

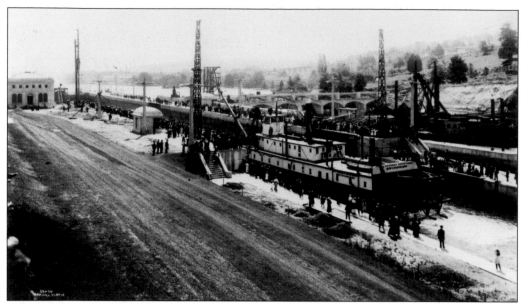

LOCKS. A large crowd turns out on a snowy day to see the locks. A letter from the War Department, written November 1, 1918, by district engineer W. T. Preston, informed George W. Putman of his appointment as lockman at a salary of $100 a month. A four-bedroom house in Sunset Hill could be purchased for that salary in 1918. (Courtesy Army Corps of Engineers.)

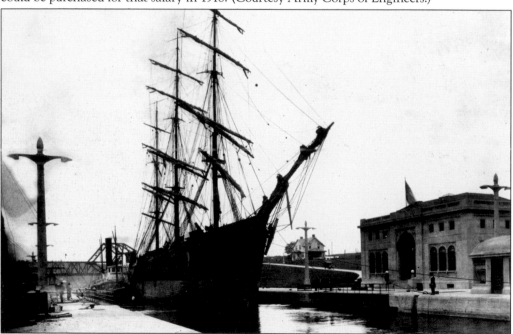

LOCK TRAFFIC, 1916. The *Abner Coburn*, built in 1882 and weighing 1,972 tons, heads up through the large lock accompanied by the tug *Wanderer*. The lockkeeper's house sits alone on a hill in the background. Carl English of the Army Corps of Engineers transformed the construction site into gardens in an English landscape style. All told, he spent 43 years planting and tending. Today the gardens contain more than 500 species and 1,500 varieties of plants from around the world. (Courtesy Seattle Municipal Archives.)

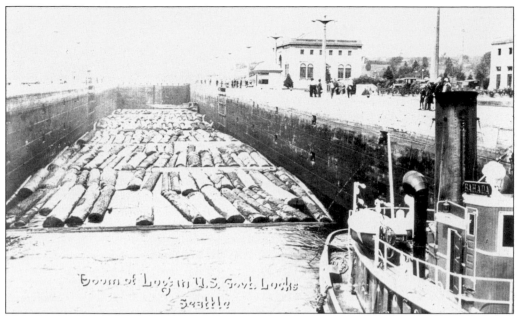

POSTCARD OF THE LOCKS. A log boom makes its way through the locks around 1920. This was a common sight in Ballard through the 1960s, but is rarely seen today. (Courtesy Clinton White.)

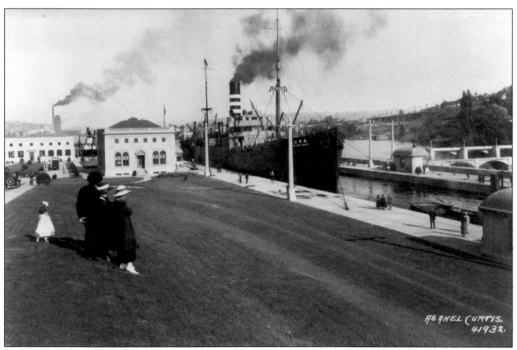

LOCK TRAFFIC. The SS *Haraison Maru*, a large Japanese freighter, navigates the large locks. Construction of the locks changed commerce in the Seattle area forever, allowing oceangoing vessels to pass through to Lake Washington. Note the little girl in the background; the Hiram Chittenden Locks are still one of the biggest tourist attractions in Washington State. (Courtesy Army Corps of Engineers.)

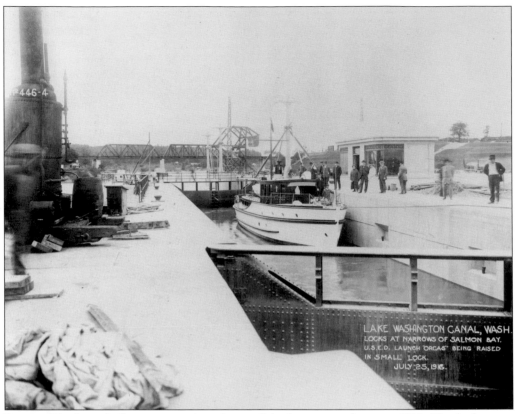

LOCKS. The launch *Orcas* is raised in the small locks on a trial run in 1916. The locks were publicly dedicated on July 4, 1917, and are open to ship traffic 24 hours a day. (Courtesy Army Corps of Engineers.)

ROAD GRADING, 900 BLOCK OF FIFTY-SEVENTH STREET. The width of roads was determined by the space two teams and wagons traveling toward each other would need to pass. Many roads in Ballard are wider than others to accommodate either streetcars or railroads; one example is Fourteenth Avenue NW, originally known as Railroad Avenue. With incorporation into the City of Seattle, many street names were lost. (Courtesy MOHAI.)

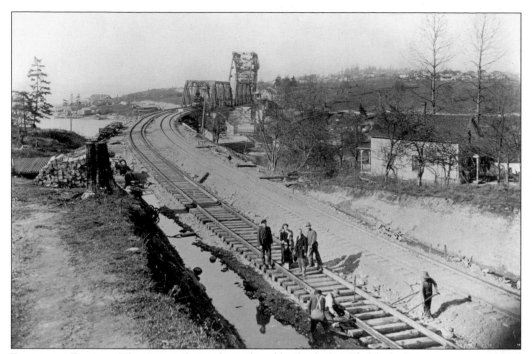

RAILROAD BRIDGE. This image shows the railroad bridge before Shilshole Avenue was completed in the 1930s. The *Ballard News* described Shilshole as "dirty, dusty, and disgraceful." Residents raised the money to pave the parking lot at the locks. (Courtesy Seattle Municipal Archives.)

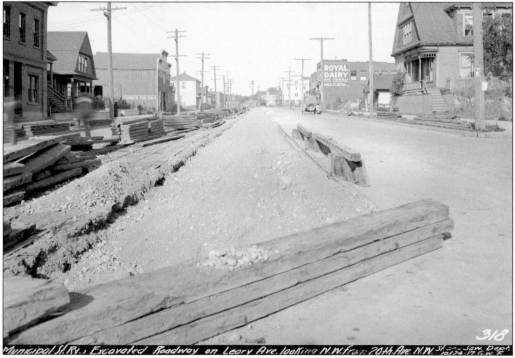

PAVING LEARY WAY. Road paving begins on Leary, with the Royal Dairy in the background of this 1917 view. (Courtesy Seattle Municipal Archives.)

ROAD CONSTRUCTION, FIFTEENTH AVENUE. Dusty in the summer and muddy in the winter, the wood plank roads were little improvement. When Ballard decided to pave the roads and build concrete sidewalks in 1917, it was determined that the property owners fronting the streets would pay for the paving, despite a flurry of protests. (Courtesy Seattle Municipal Archives.)

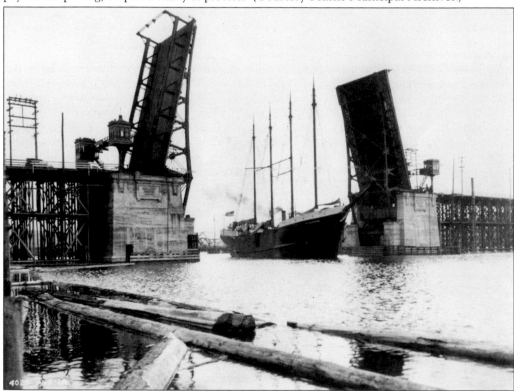

BALLARD BRIDGE. The Ballard Bridge was moved from Fourteenth Avenue NW (Railroad Avenue) to Fifteenth Avenue in order to accommodate a drawbridge once the locks were built. The first span, built in 1888, was of split logs; this image shows the 1918 bridge, the approaches were replaced in 1940. (Courtesy MOHAI.)

Four

BALLARD AVENUE AND BEYOND

Ballard's first business district sprang up on Ballard Avenue around the mills and shipyards. The first grocery store, on Ballard between Second and Park, was built by A. H. Sharpe in May 1889 and included the post office in one corner. In the fall of 1890, the first hardware store was constructed by a Mr. McNaughton and a Mr. McCullough. A. W. Preston served as Ballard's first pharmacist, with a building at 5311 Ballard Avenue completed in 1901. A self-contained city, by incorporation Ballard boasted a Leary Way blacksmith, grocery stores, feed stores, livery stables, several banks, hotels, hardware stores, butcher shops, a pharmacy, dry goods, milliners, and clothing stores. By 1905, it would include dressmakers, an ice-cream factory, Pop's Candy Store, haberdashers, department stores, and laundries as the center of commerce—not only for Ballard, but for Queen Anne and Magnolia as well.

Ballard Avenue was not the only commercial section of Ballard during the second decade of the 20th century. Before the advent of the supermarket, virtually every major thoroughfare in the city boasted a number of small "Mom and Pop" markets with proprietors living above them.

The early 1920s were boom years for Ballard, and many of the buildings on Market Street still exhibit art deco flourishes in their brickwork. In 1923, the Eagles built the Eagles Building, now known as the Ballard Building, for a cost of $425,000. The space included offices on the second and third floors; a dining room, gymnasium, smoking room, and kitchen in the basement; and the Bagdad Theatre on the first floor, along with a department and hardware store. The Eagles Building was widely regarded as the most "lavishly appointed on the West Coast," despite an inaccurate plaque on Ballard Avenue referring to the Eagles' temporary home while the structure was being built. Lafferty's Pharmacy would take the place of Hurd's Drugs, and the Baghdad would eventually become the Backstage, now a bakery. Once the Eagles Building was constructed, the focus of commerce shifted to Broadway (Market Street) for the next 75 years.

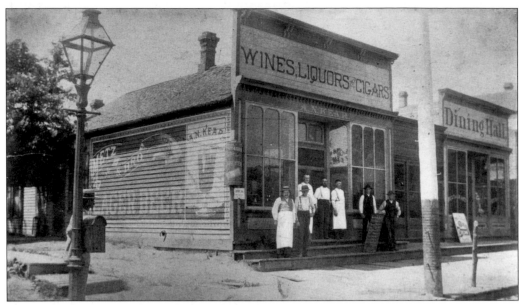

LIQUOR STORE. One of the earliest views of Ballard, taken around 1890, shows the liquor store and restaurant. (Courtesy MOHAI.)

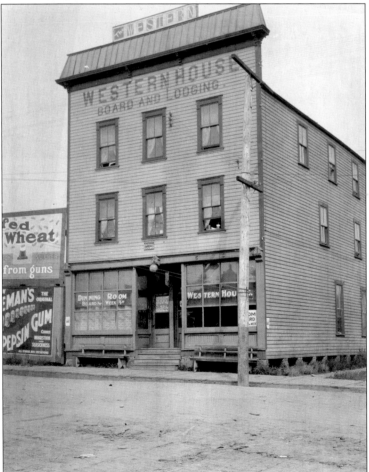

WESTERNHOUSE BOARD AND LODGING. The Westernhouse Board and Lodging boardinghouse, pictured in 1910, was located at 5240 Leary Avenue. Several old boardinghouses still stand in Ballard, including this building, which now houses the Senor Moose Café; one on Market scheduled to be torn down; and one on Fourteenth Avenue NW. (Courtesy University of Washington.)

BALLARD AVENUE, 1910. This northward view from Twentieth Avenue reveals the historic district of Ballard Avenue looking surprisingly similar to today. Because of the work of the Landmark Committee of the Seattle City Council in 1976, historic buildings like these remain. (Courtesy author's collection.)

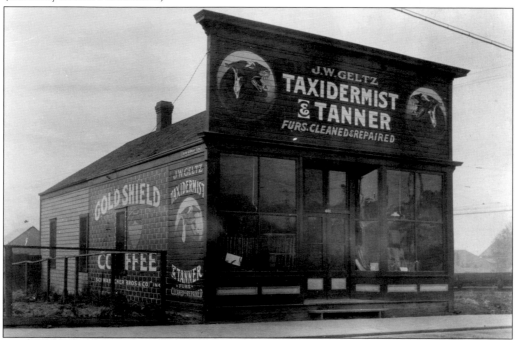

J. W. GETZ TAXIDERMIST ON LEARY WAY. Furriers were much more common in an earlier age, since both sexes wore fur coats. Until the 1970s, two furriers operated in the neighborhood: one on Holman Road and Victor Nelson Furs on Eighty-third and Greenwood. (Courtesy University of Washington.)

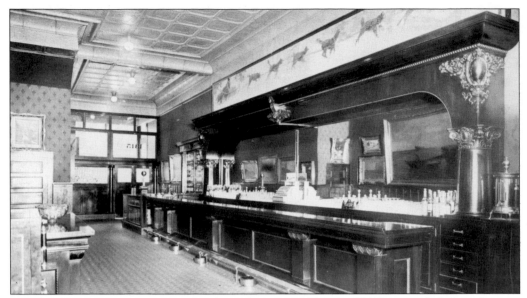

BALLARD TAVERNS. Acquiring its first liquor license in 1900, the Old Home included a mahogany bar that came around the Horn. The building, moved to allow for the Mathes Block, sold beer in the middle of the street during construction. At one time, Ballard Avenue had more saloons per square foot of boardwalk anywhere west of the Mississippi. One of the most notorious bars, the Brunswick, was owned by Mayor Peterson. With annexation to Seattle in 1907, all Ballard taverns had to reapply for their liquor licenses, pay $1,000 a year for said license, and close at 1:00 a.m. and on Sundays. (Courtesy Olympic Athletic Club.)

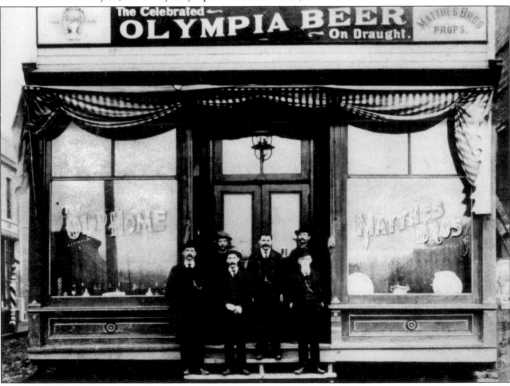

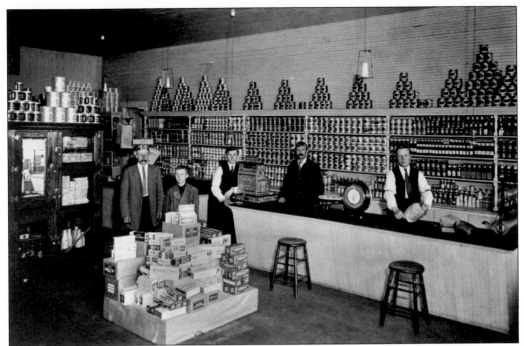

GROCERIES. Groceries all provided home deliveries, constituting a welcome source of income to small boys with bicycles. Virtually all Ballard businesses delivered, including the iceman, bakery, dairy, laundry, grocer, fishmonger, and butcher. Kastner's Meat Market on Twentieth Avenue even delivered twice a day. Many of these early-20th-century stores can still be seen around Ballard, reincarnated as homes or other businesses. Koll and Wick's Grocery (above) was located at 5801 Fourteenth Avenue NW, while the Illinois Grocery, pictured below in 1910, stood at the corner of Leary and Seventeenth NW. (Courtesy MOHAI.)

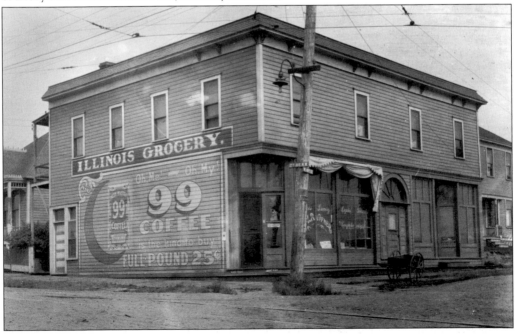

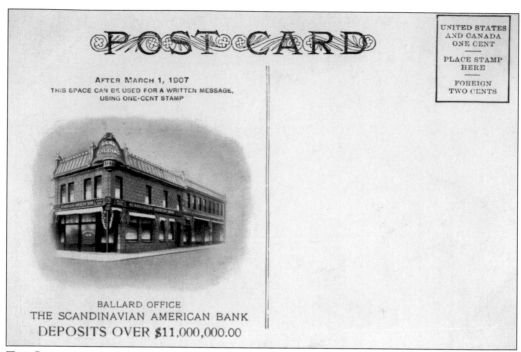

THE SCANDINAVIAN BANK. The Scandinavian Bank on Ballard Avenue was a branch of the parent company downtown in the Arctic Building. This building would be reincarnated as the Harvey Rooms, a notorious brothel, and later as the Starlight Hotel. (Courtesy Dave Wolter.)

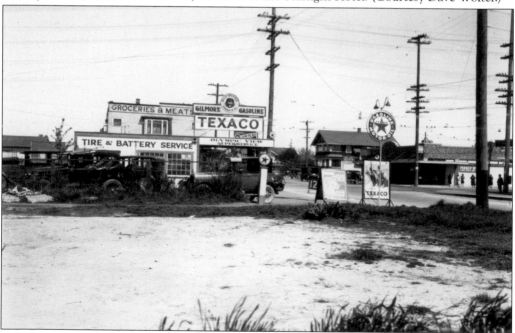

GAS STATION. This station, seen in the 1920s, was situated at Eighty-fifth Street and Fifteenth Avenue. Notice the Piggly Wiggly and the pool and card room in the background. Gambling was not allowed within the city of Seattle; at the time, the city limit was at Eighty-fifth Street. (Courtesy University of Washington.)

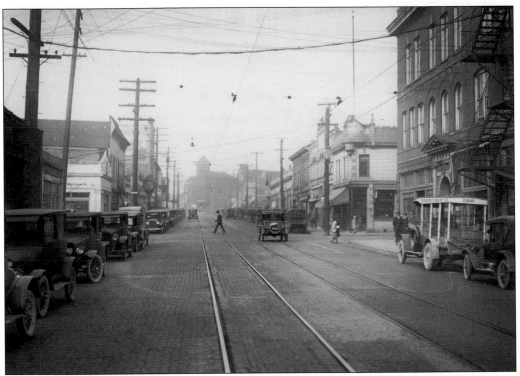

BALLARD AVENUE. This 1925 view shows the Ballard Savings and Loan, Canal Bank, and the Mathes Block (which included a secondhand store) with city hall in the distance. (Courtesy University of Washington.)

ADVERTISEMENTS. The W. M. Curtiss Company, featured here, was a hardware store originally occupying the first floor of the Curtiss Building on Leary, which has been mostly converted to apartments. The Ballard Ice Cream Factory boasts that its product is "Guaranteed to keep one hour, always on Hand." This was a selling point in the days of the icebox and the iceman! (Courtesy author's collection.)

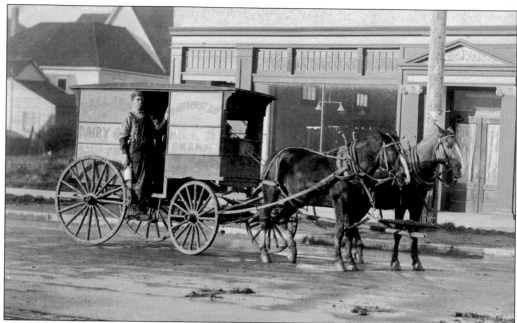

ROYAL DAIRY WAGON. Milk was delivered by horse and cart in Ballard into the 1920s. This photograph was taken on Thirty-second and Sixty-fourth NW, in what was then called the Gilman Addition and is now Sunset Hill. The road would not be paved until 1917. Fresh vegetables and milk were also delivered daily from the Ballard-Suquamish ferry, and each morning the ferry would discharge farmers from the other side of Puget Sound to sell their wares. (Courtesy University of Washington.)

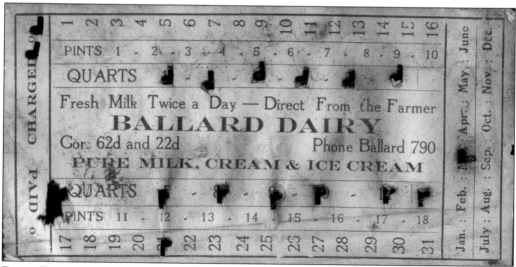

DAIRY RECEIPT. The Ballard Dairy was located at the corner of Sixty-second and Twenty-second NW and delivered twice daily, as did Kastner's Meat Market on Twentieth Avenue. Most early Ballard merchants delivered their goods by horse and cart on a regular schedule. This receipt was found in the Soderlund house, built in 1904 on Sixteenth and Seventieth, still standing and still occupied by descendants of the original family. (Courtesy Laura McLeod.)

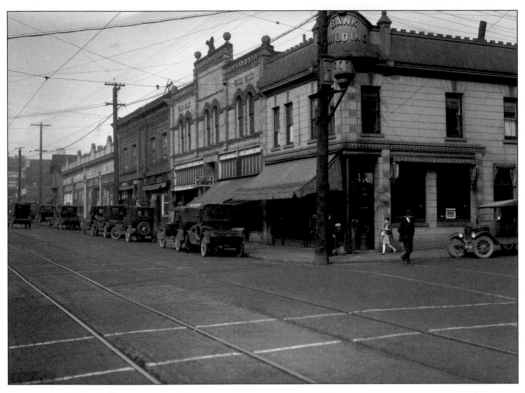

BALLARD AVENUE. These images of Ballard Avenue from October 19, 1925, show how little it has changed over the years. The Ballard Savings and Loan advertises a six-percent rate!

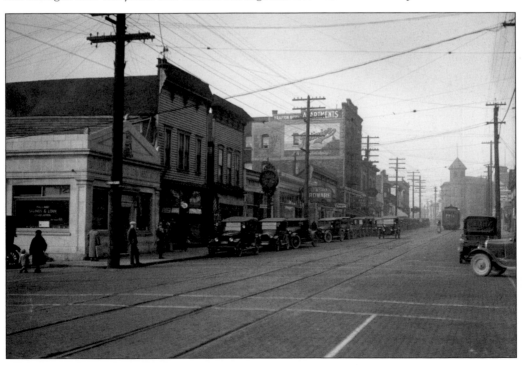

END OF THE LINE. This refreshment stand, pictured in 1910, stood at the end of the streetcar line at Thirty-sixth and Sixty-fourth Avenues in Sunset Hill. It was a popular area; H. Jacobsen Groceries was located nearby at Northeast Thirty-sixth and Sixty-fifth NW, on the way to Ballard Beach. (Courtesy MOHAI.)

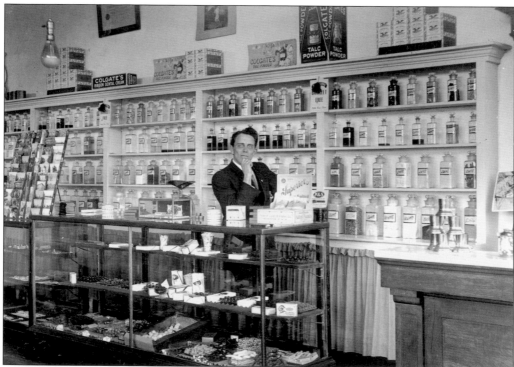

DRUGSTORE AND BARBERSHOP. In 1910, this combination drugstore and barbershop was operating at Thirty-second and Sixty-fourth Street in the Gilman Addition, what would become Sunset Hill. Contrary to popular rumor, the rooms above the store were apartments and not a brothel or other den of iniquity. (Courtesy MOHAI.).

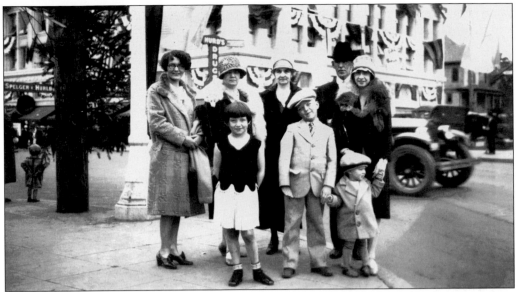

THE EAGLES BUILDING, MAY 17, 1927. Jack Pheasant, presumably taking the photograph, was one of five men responsible for the building's construction and served as first chairman of the board of the fledgling Ballard Hospital, located on the third floor. Pictured here are, from left to right, (first row) Renee Pheasant, Robert Pheasant, and C. O. D. Pheasant; (second row) Ethel Pheasant, two unidentified, Clyde Bailey, and unidentified. (Courtesy author's collection.)

YOU ARE CORDIALLY INVITED TO ATTEND
THE OPENING OF

JENSEN & VONHERBERG'S

BAGDAD THEATRE

MARKET STREET NEAR BALLARD AVENUE

SATURDAY, MAY 28TH, 1927

KINDLY PRESENT THIS INVITATION PRIOR TO 7:00 P. M.

LEROY V. JOHNSON, GENERAL MANAGER

GRAND OPENING, BAGDAD THEATRE. The Bagdad was just one of many theaters in Ballard, including the Majestic (renamed the Roxy, then the Bay), the Crystal, the Woodland, and the Bat. The Bagdad was reincarnated as the Backstage in the 1970s, and eventually would become part of what is now the Ballard Athletic Club. The entrance can still be discerned in the slight rise in the bakery that stands on the site in the Ballard Building.

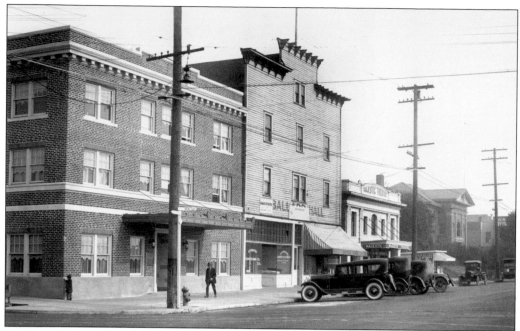

MARKET STREET. In 1925, Market Street included, from left to right, Ballard Hall, the Majestic, and the library. The building on the corner housed Pheasant-Wiggen Mortuary and, in later years, a Sears store. The apartments on the upper floors have not changed significantly since the building was constructed in 1923. (Courtesy University of Washington.)

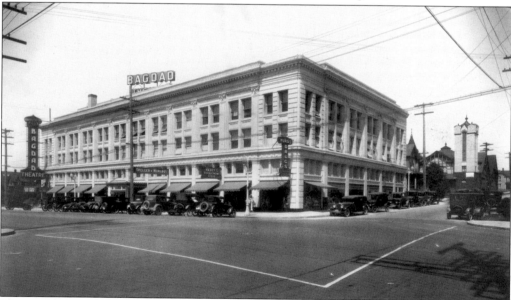

MARKET STREET. This image shows the Eagles Building without its current upper stories, along with a clear view of the businesses along Market Street. The neighborhood was changing from residential to commercial; the author's grandparents' house can be seen behind the building, and a church stands where Bartell Drugs is located today. The focus of commerce in Ballard would shift from Ballard Avenue to Market Street in the 1920s, and remain unchanged for another 75 years. (Courtesy author's collection.)

Five

SHINGLE CAPITAL OF THE WORLD

The first mill was the Sinclair mill, completed in January 1888, followed by another built by J. Simpson and the West Coast Improvement Company at the foot of Second Avenue in January 1889. The next was constructed in 1890 by the Seattle Cedar Lumber Company, and then two facilities were built for George Stimson, a mill owner from Michigan. The first mill furnished the lumber for the others and for mill workers' houses in the booming economy. At the height of the boom, 29 mills were functioning in Ballard. The first frame house built in Ballard was in fact the cookhouse for the Seattle Lumber Company.

In the summer of 1889, William Ainsworth constructed a large plant known as the Seattle Steel and Iron Company, which operated in 1889 and 1890 and which was also considered a compelling reason for the boom in Ballard. Paul Hopkins built the Ballard Boiler Works in 1889, yet another important business.

Ballard was home to both shingle mills and sawmills, but the shingle mills really started the city's boom. By 1895, Ballard was given the title "Shingle Capital of the World," producing more shingles than any other town worldwide and employing 570 men. Of Seattle's 31 shingle mills, 10 were located here. Fortuitously for Ballard, in 1889, one year before incorporation, the Great Seattle Fire consumed every lumber mill, wharf, and warehouse between Union and Jackson. About 30 square blocks of the downtown core were destroyed in a raging inferno that would burn to the waterline. Much of the lumber needed to rebuild Seattle came from Ballard, and Seattle's misfortune created an enormous economic explosion for Ballard.

By 1904, Ballard had 20 mills and a daily output of three million shingles. Shingle Weavers' Union Local No. 12 went on strike unsuccessfully in 1906 and 1913 for a wage increase to attain equal pay to those in Everett and Bellingham. The mills replaced most of the strikers with scabs, and business continued as usual. According to myth, a young man entered Seattle Cedar to apply for a job, and the manager asked him to chop off a finger on the spot, saying, "We'll take the rest as necessary." Although not true, it is indicative of the potential danger mill work involved.

Machine shops, metal foundries, marine engine shops, paint manufacturers, boilermakers, and many other small manufacturers also established themselves along the shoreline, servicing both the lumber and marine industries.

SEATTLE CEDAR MILL. Once the largest mill of its kind in the world, this structure was built in 1890, and much (65 percent) was destroyed in a Seattle fire in 1958. Though the mill was rebuilt, it ultimately closed for want of cedar. The man standing on the spreader board gives a sense of scale. (Courtesy Swedish Hospital.)

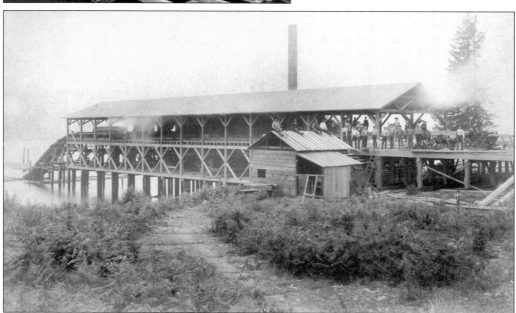

CANAL LUMBER. Between 1901 and 1921, the International Shingle Weavers' Union was one of the biggest, most powerful unions in the Pacific Northwest. About 1890, shingle weavers of Puget Sound formed the West Coast Shingle Weavers' Union. Three years later, mill owners formed an alliance calling for an industry-wide wage reduction. The Shingle Weavers' went on strike, and three months later the Panic of 1893 hit. This depression was the death knell of the second organizing attempt. The third and by far the most successful and longest-lasting attempt began in 1901. (Courtesy University of Washington.)

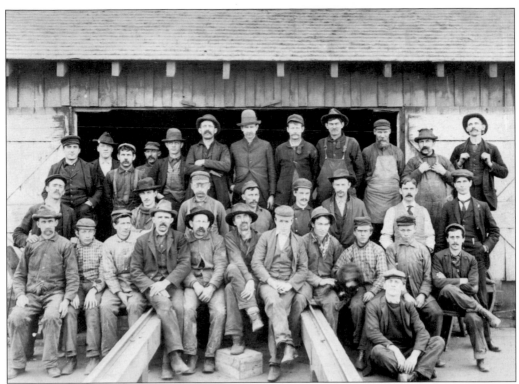

MILL WORKERS AT SEATTLE CEDAR. Mill work was exceptionally dangerous and notoriously underpaid, and many of these men are probably missing a digit or two. On April 1, 1906, a strike started in Ballard. Three months later, with little sign of an agreement or even negotiations on the horizon, the union made the decision to expand the strike. On July 17, a general strike of all shingle mills in the state was called—the most complete tie-up of the shingle industry in history. For the first time since 1901, the manufacturers were too strong and too many strikebreakers were available; the strike was called off in August 1906. (Courtesy MOHAI.)

CAMPBELL MILL. Napoleon Campbell's shingle mill was condemned in 1915, when the locks were being built and the water level rose 14 feet. (Courtesy Seattle Municipal Archives.)

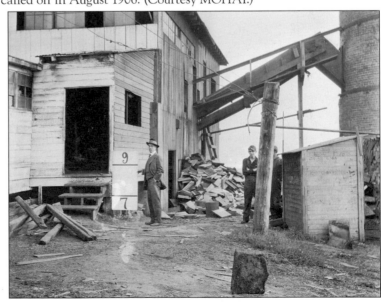

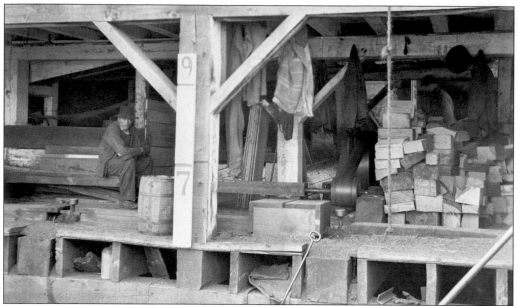

CANAL LUMBER COMPANY. Near the fuel hopper at the Canal Lumber Company, a worker sits on a pile of lumber, looking glumly at the camera; as well he should—mill work was notoriously risky and poorly paid. (Courtesy Seattle Municipal Archives.)

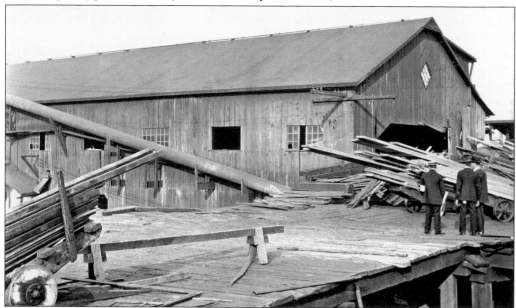

CANAL LUMBER COMPANY MILL. These photographs of the condemnation were taken by the City of Seattle in 1915. In a petition to the Army Corps of Engineers, 1300 Salmon Bay property owners wrote the following: "The lumber mills located upon the shore of Salmon Bay are opposing the construction of the locks to said canal at the present government site near the mouth of said Bay, for the reason, as they say, that it will prevent them from bringing in logs as conveniently as they can do without locks, and the further reason, quietly admitted, that they will have to raise their manufacturing plants if the locks are placed at the present locks site, by reason of the increase in the depth of the bay about fourteen feet." (Courtesy Seattle Municipal Archives.)

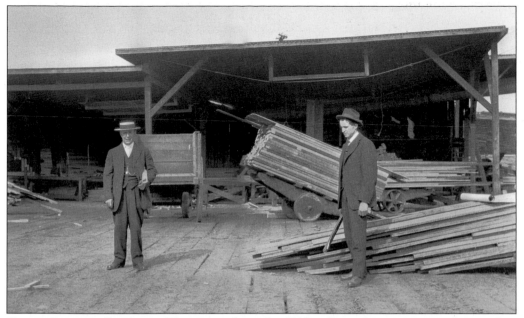

CANAL LUMBER COMPANY. This image from the 1915 mill condemnation period was taken from the upper platform near the kiln and shows the end of the sawmill building. A Mr. Talbot appears on the left, while a Mr. Bourque is on the right. One mill went so far as to create a dam instead of moving its operation; the machinery was actually located below the waterline. (Courtesy Seattle Municipal Archives.)

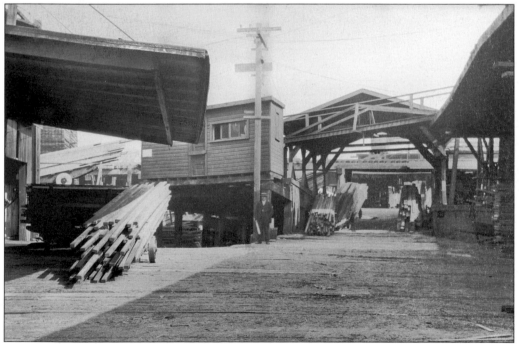

CANAL LUMBER COMPANY, 1915. Kiln drying greenwood was important to reduce warping; however, the kilns were a constant source of fire danger in Ballard. (Courtesy Seattle Municipal Archives.)

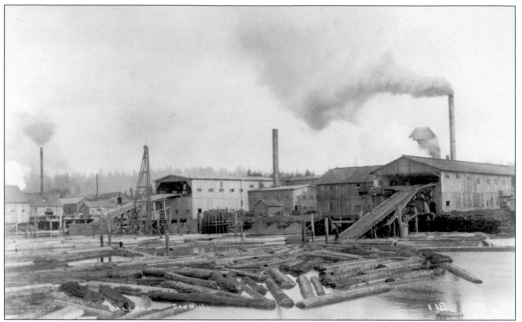

BALLARD FROM MAGNOLIA. Taken from Fishermen's Terminal, this 1914 panoramic view shows the Ballard waterfront with the mills in full production. (Courtesy Clinton White.)

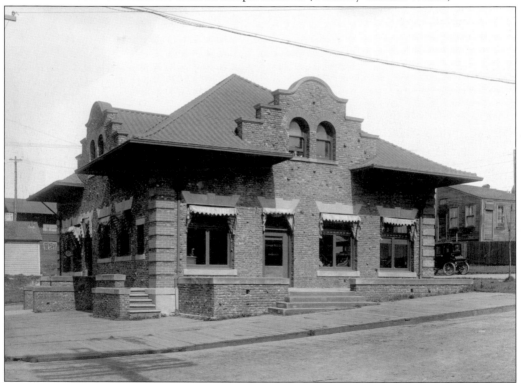

MILL OFFICE. The Stimson Mill office was built in 1913 and designed by Spokane-based architect Kirtland Cutter, responsible for such Seattle landmarks as the Rainier Club and the Stimson-Green Mansion. (Courtesy MOHAI.)

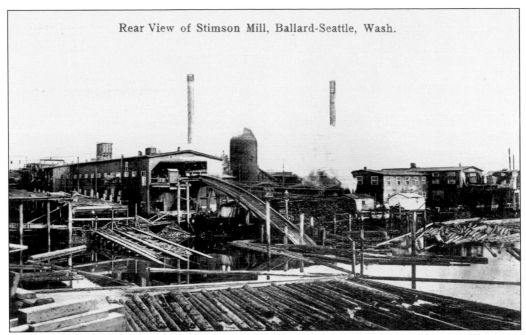

Rear View of Stimson Mill, Ballard-Seattle, Wash.

STIMSON MILL, 1904. George Stimson owned two of the earliest mills in Ballard. His foreman, George Startup (for whom the town of Startup is named), served as Ballard mayor from 1897 to 1898. (Courtesy Dave Wolter.)

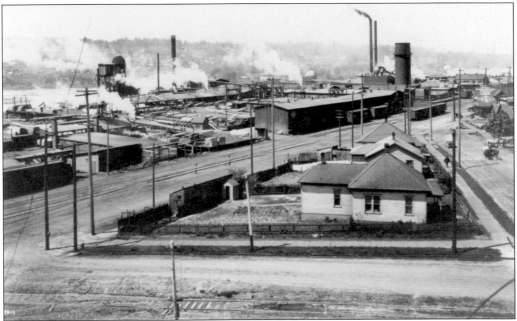

BOLCOM LUMBER COMPANY. In 1910, Asahel Curtis took this photograph of the Bolcom Lumber Company at 1540 Forty-sixth Avenue NW. The area is now mostly marinas, but the odd triangular block remains. (Courtesy University of Washington.)

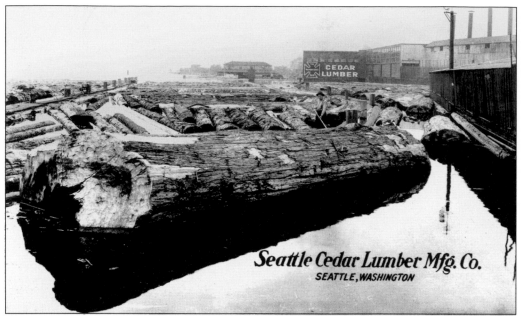

SEATTLE CEDAR. This vintage postcard of the Seattle Cedar Company is faded, but one can still make out the man riding the booms amongst the enormous old-growth cedar. The reverse reads, "A Washington Red Cedar Log—7 ft. 9 in. diameter at small end. 10 ft. 6 in. diameter at big end. Age 1340 years. The sawn lumber in the log would make enough 1" x 1" to reach from Philadelphia to Atlantic City. Enough 6" siding to cover ten eight room houses. Enough to make a 4" x 4" post ten times as high as the Woolworth Building. Enough to make a 3" x 3" post so tall that it would exceed by over 3,000 ft. the height of Mount Rainier, the highest mountain in the land." (Courtesy Clinton White.)

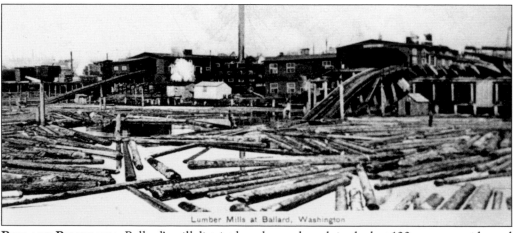

BALLARD PANORAMA. Ballard's mill district has changed much in the last 100 years, as evidenced by this panoramic postcard view. The huge log booms in Salmon Bay are a distant memory. (Courtesy Clinton White.)

Six

SHIPBUILDING, FISHING, AND MESSING ABOUT IN BOATS

The maritime industry of Ballard coincided with the influx of Scandinavian immigrants in the 1880s and the ready source of local timber for boatbuilding. Many immigrants brought their shipbuilding and carpentry skills with them, working as fishermen in the summer and as carpenters, shipwrights, and cabinetmakers in the winter. The Puget Sound fishery was fished out early, and Ballard fishermen had to go into Alaskan waters. Fishermen went after herring, cod, salmon, halibut, and crab—depending on the season—moving farther up the Inside Passage and the Aleutians. Besides the halibut schooners, purse seiners, gill netters, and trollers could be seen leaving Ballard for the grounds. Until the 1920s, fishing was done under sail, by hand, usually with small dories, and was a dirty, difficult, and dangerous occupation.

The Deep Sea Fisherman's Union of the Pacific was formed in 1912 to try and address the concerns of fishermen, mainly long-line halibut and crab fishermen. The monument at Fisherman's Terminal remains a testament to the over 677 men and women who have lost their lives in the fishing industry since 1900. In 1913, Ballard's Fishermen's Terminal was given to Seattle's commercial fishing fleet by the Union Pacific Railroad with the Port of Seattle acting as caretaker on the Magnolia side of Salmon Bay, and the government locks were completed in 1917. In 1929, Pastor Ole Haavik of Ballard First Lutheran started the first Blessing of the Fleet, a tradition carried on to this day.

In 1910, more than 1,300 residents signed petitions to the secretary of war in Washington, D.C., expressing their concerns about the location of the Ballard locks. The mill owners wanted the locks built at the head of the bay rather than at their present location, a request that would have flooded many of the shipyards. Forward-thinking Ballardites knew that although the mills provided employment for large numbers of men, the days of the huge shingle mills were numbered. Not one shingle mill remains today, but Ballard retains its maritime flavor.

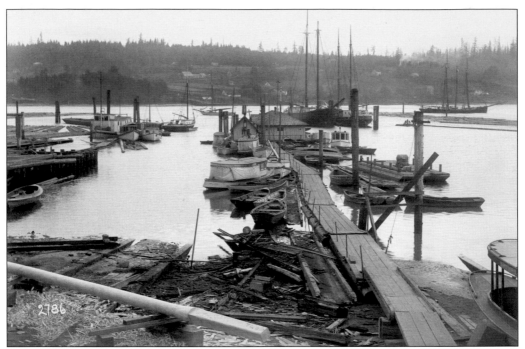

BALLARD BOATHOUSE. Boathouses rented boats and ferried passengers to larger ships. The Jacobsens originally had a boatyard on the Magnolia side and would row across the canal to work. The family eventually parlayed the boathouse business into a pleasure boat business that survives today. There were about a dozen boathouses and boatyards—not to be confused with shipyards. (Courtesy Bob Jacobsen.)

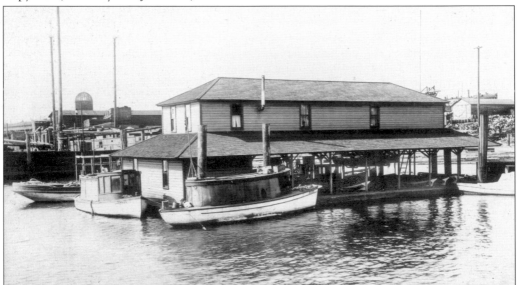

ANDERSON'S BOATHOUSE. At the foot of Twentieth Avenue, Anderson's was a tug and transport operation that ferried passengers between 1891 and 1942 to larger ships, and people to and from Magnolia to work and church on Sundays. The smaller boat is the *Mystery*, and the larger boat is the *Floyd*, named after Capt. Fred Anderson's son Floyd, born in 1911 in the family residence above the boathouse. (Courtesy Margaret Anderson.)

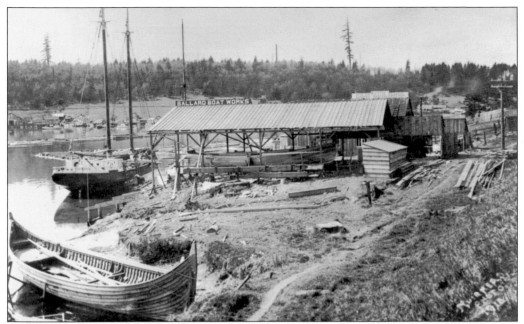

BALLARD BOAT WORKS. Started in 1905 by Sivert Sagstad, the Ballard Boat Works was located just west of where the government locks are today. In 1917, the operation was moved to its present site at Fifty-first and Shilshole. The *Viking* replica in the foreground was built for the 1909 Alaska-Yukon-Pacific Exposition. (Courtesy Heggem family.)

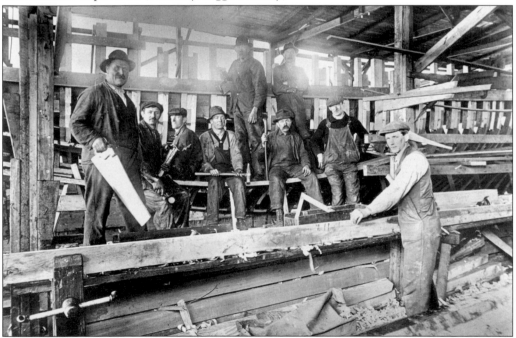

SHIPYARD WORKERS. The Sunset Boat and Engine Company had become the largest distributor of Frisco standard engines in America by 1914. Here owner H. Starrett stands with a saw. Many shipwrights and carpenters were Scandinavian immigrants with skills suited to the industry. (Courtesy University of Washington.)

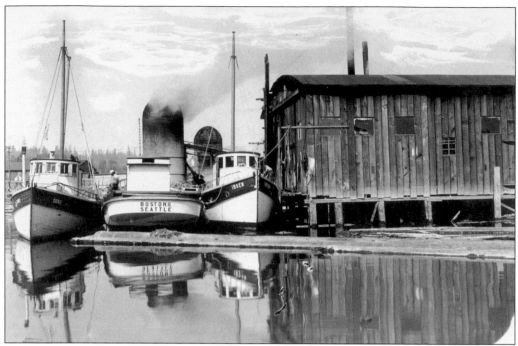

SUNSET BOATYARD. The Sunset Boatyard was situated at the foot of Twenty-sixth Avenue. In this 1915 image, the three boats rafted up appear to be purse seiners. The buildings were flooded with the opening of the locks. (Courtesy Heggem family.)

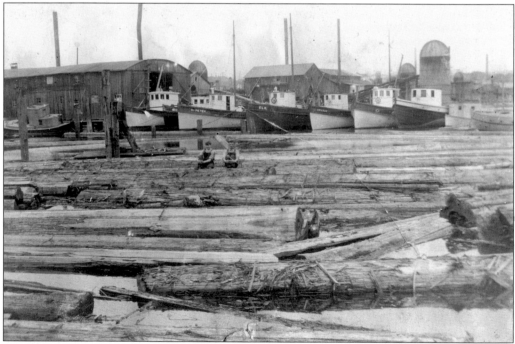

TYPICAL BALLARD SCENE. This scene, in which halibut boats at the boatyard compete for space with a log boom from the mills, typifies the industry that made Ballard a city unto itself. (Courtesy Heggem family.)

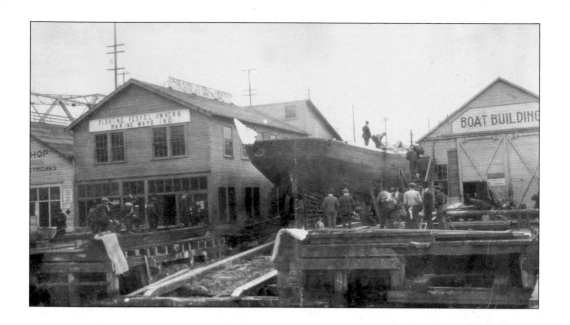

FISHING VESSEL OWNERS MARINE WAYS. The *Paragon*, above in the ways and below being launched, was designed and built by Ingvald Heggem at the Fishing Vessel Owners Marine Ways on Railroad Avenue (Fourteenth) in 1923. A three-quarter-scale sculpture of the boat exists on the Duwamish River today. The *Foremost* and the *Eagle* were constructed from the same plans. (Courtesy Heggem family.)

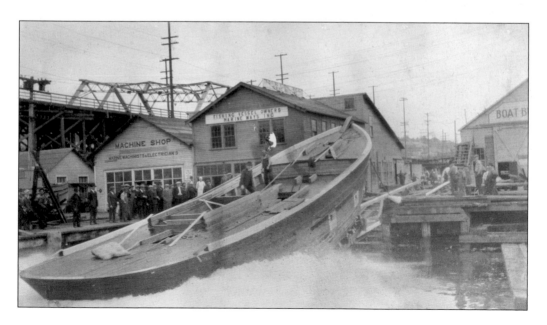

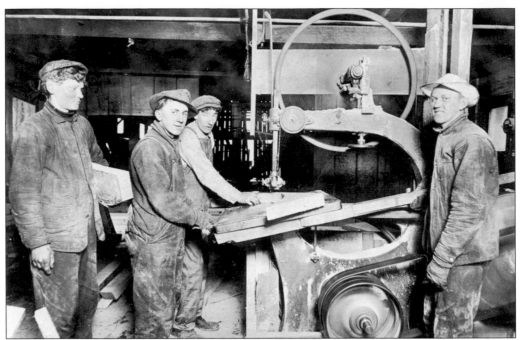

SUNSET BOAT WORKS. This rare interior photograph depicts shipyard employees at work. (Courtesy University of Washington.)

INGVALD HEGGEM. Heggem was considered by Harold Lokken to be the "dean" of Ballard shipbuilding. He did his apprenticeship in ship construction in Bergen in 1904 at Brunchorst and Dekke. During his lifetime, Heggem built many ships (his own numbering system suggests 78), including 16 halibut schooners, many of which are still afloat today. (Courtesy Signe Heggem Davis.)

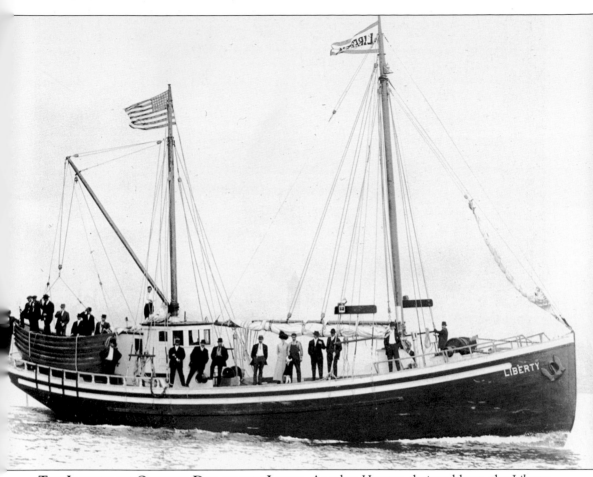

THE *LIBERTY* ON OPENING DAY AT THE LOCKS. Another Heggem-designed boat, the *Liberty* was built in 1913 at the Sunset Boatyard. When asked by a judge in his citizenship hearing what he knew about the Constitution, one immigrant exclaimed, "I know all about the *Constitution*, and the *Liberty* too. Ah, they're beautiful ships, and Ingvald Heggem built them!" (Courtesy Signe Heggem Davis.)

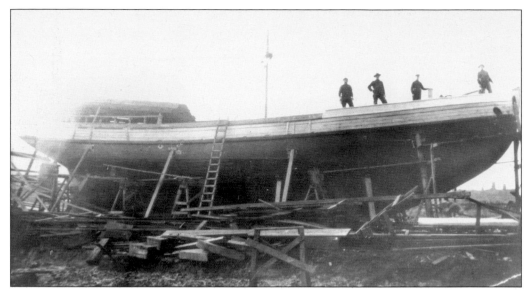

THE ALBATROSS. Commissioned by the Linvog brothers, the *Albatross* was constructed by Ingvald Heggem and Eilert Erickson at the Sunset Boatyard in 1910. The boat was involved in a major accident in 1936, when she lost the entire above-deck structure but made it home safely with no loss of life. The *Seattle Post-Intelligencer* ran a front-page article on May 29, 1936, detailing the accident. The *Albatross* was later converted into a seiner, keeping her distinctive rounded bow. (Courtesy Heggem family.)

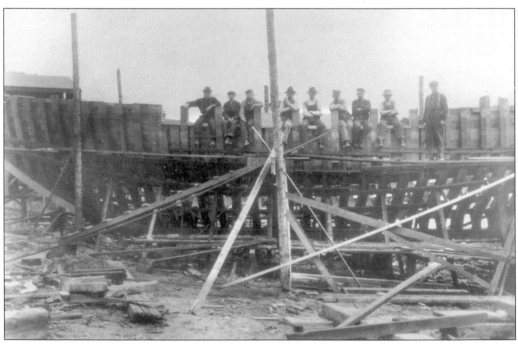

BUILDING THE *LIBERTY*. The shipyard crew lines up on the skeleton hull of what would become the *Liberty*. (Courtesy Heggem family.)

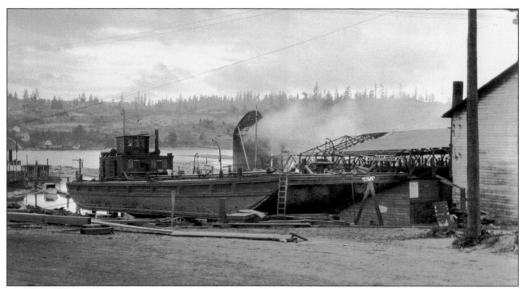

BALLARD MARINE RAILWAY. While other boatyards specialized in schooners or yachts, the Ballard Marine Railway was noted for its barges. Reincarnated as Pacific Fishermen, the operation now builds ships of all descriptions and performs repairs. (Courtesy Seattle Municipal Archives.)

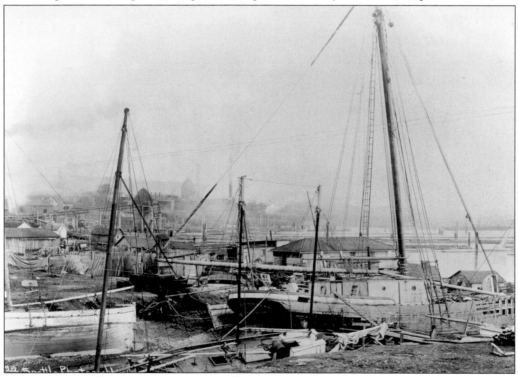

BALLARD BOAT WORKS. The boatyards of Ballard turned out some of the most beautiful halibut schooners ever built, and at least 30 of them survive to this day. Tregoning, Ballard Boatyard, Sagstad's, Sunset Boatyard, Sunset Boat and Engine, Allen's, Cooke and Lake, and Hansen's all produced world-class ships. Names like Berg, Hansen, Jacobsen, and Heggem were synonymous with boat designs, and many of their blueprints reside in museums today. (Courtesy MOHAI.)

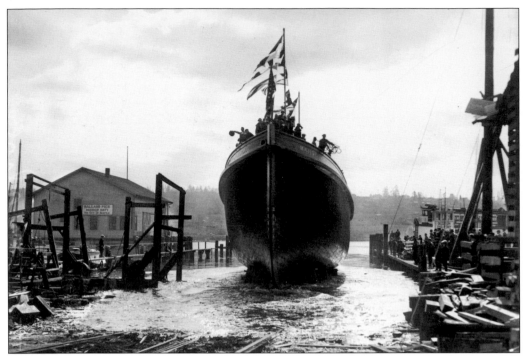

THE MAHOE. The ocean tug *Mahoe* was built at the Ballard Marine Railway Company for a Honolulu firm. At the time of its launching, the 120-foot tugboat was the largest diesel tug in the world. The *Mahoe* is seen here during the April 1925 launch ceremony in Ballard. (Courtesy MOHAI.)

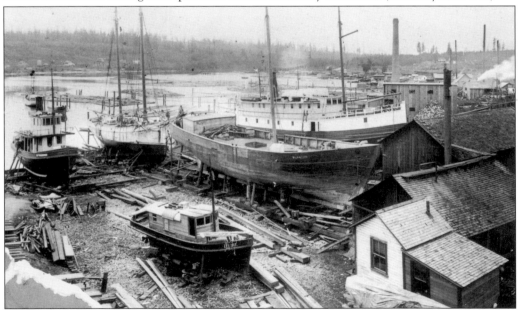

SHIPYARDS. Pictured is a rare view of the Ballard shipyards in the early 1900s. An entire industry was built around fishing, with shipyards, dry docks, net lofts, machine shops, navigational suppliers, ship's chandlers, and icehouses springing up in Ballard. The hotels, bars, pool halls, dance halls, and brothels on Ballard Avenue served the single fishermen as well as the mill workers. (Courtesy University of Washington.)

74

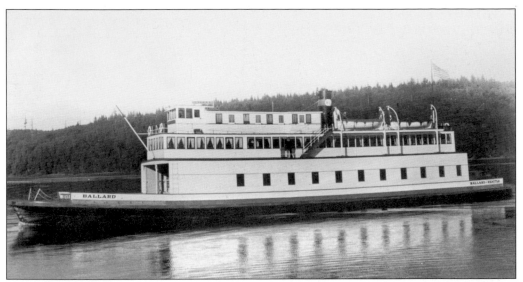

THE BALLARD FERRY. Constructed in 1900 as the *City of Everett* and renamed the *Ballard* in the 1920s, this ferry worked the Suquamish-Indianola-Ballard route for many years. Sold off by Black Ball, she opened as the upscale Four Winds Restaurant and later as the Surfside 9 on Lake Union, where she sank not once, but twice. She sailed out of Ballard near the current site of Ray's Boathouse, and children would dive for coins that passengers threw overboard. A ferry also ran to Port Ludlow for many years. (Courtesy Steve Pickens.)

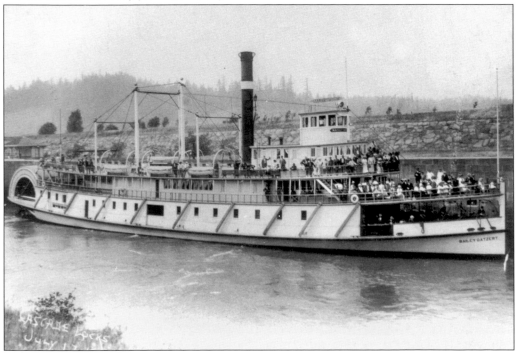

THE BAILEY GATZERT. Named after the only Jewish mayor of Seattle, the *Bailey Gatzert* was built in 1890 for Ballardite John Leary and launched sideways on 177 footways in 1891. The most famous of all Columbia River stern-wheelers, she was the fastest ever built. (Courtesy Two Rivers Museum.)

BALLARD SHIPYARDS FROM THE WATER. This rare image shows the Ballard Marine Highway (now Pacific Fishermen) and Twenty-fourth Avenue NW. The Broadway School is visible in the distance. (Courtesy University of Washington.)

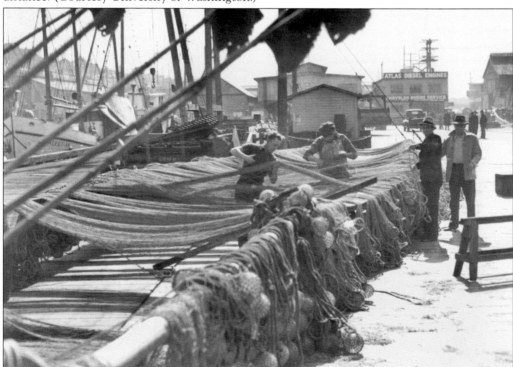

FISHERMEN'S TERMINAL. In 1914, the City of Seattle built the Fishermen's Terminal for the fishing fleet. Although located on the southern side of Salmon Bay, Fishermen's Terminal has always been culturally aligned with Ballard. Many shipyard workers and fishermen would take the trolley over the Ballard Bridge and descend the stairs on the other side, now closed. (Courtesy University of Washington.)

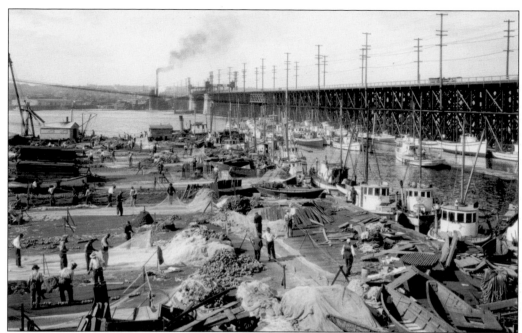

FISHERMAN'S TERMINAL. No other photograph captures all of Ballard's industry quite as well as this one, taken in 1918. In the busy scene, boats are tied up at the dock, nets drying, and the smokestacks and refuse burners of the Ballard mills are working busily away in the background. (Courtesy author's collection.)

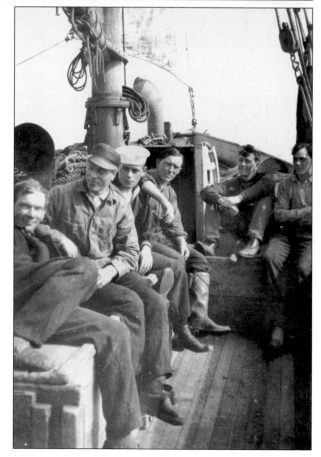

CREW OF THE HALIBUT SCHOONER ALBATROSS. Taken in April 1919, this rare view depicts the crew of an early-20th-century halibut schooner. Halibut schooners like this one are still viable contenders in the commercial fishing industry nearly a century after they were built. Pictured from left to right are unidentified, John Linvog, Gustav Heggem, Ole Goldsten, Louie Askeland, and Gus Hundvind. (Courtesy Nancy Linvog Ferkingstad.)

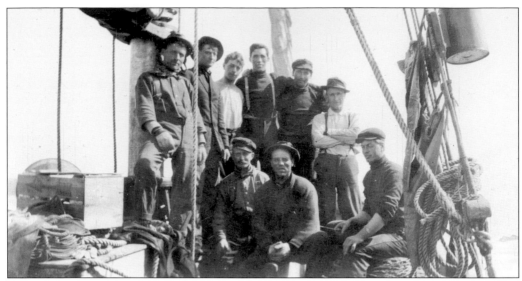

CREW OF THE ALBATROSS. Another shot of the crew reveals John Linvog at far right. He and his son Vernon owned the *Platinum* and the *St. John II*. It is rare to have photographs taken aboard a fishing vessel, as cameras were expensive and difficult to keep dry on a moving ship! (Courtesy Nancy Linvog Ferkingstad.)

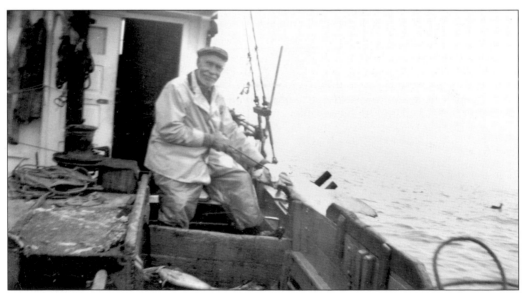

BALLARD FISHERMAN. Marcus Peterson Otnes emigrated from Otnes, Norway, as a young man and was the oldest living survivor of the sinking of the *Dix*, the most famous maritime disaster in Washington State history. He fished on the *Bertha* (named for his wife, Berit) and lived in Ballard to the age of 99. His two sons, Fred and Pete, fished together on the *Bertha* for 40 years. (Courtesy Otnes family.)

Seven

Public Schools, Parochial Schools, and the Peanut College

From the very beginning, Ballard took an interest in educating its children. The first school in Ballard was in a private home; the Ross School was originally held by Dr. John Ross in his home in 1873. Students sat at one long cedar table; eventually a proper school was built, but only the playfield remains today. The Ballard School District met on April 25, 1886, and voted, "let there being no school house it was decided to accept a house of Mr. Brygger, which needing repair it was decided to repair, and also to furnish a stove. And it was decided to hire a teacher and have school begin the last Monday in August." Thomas Burke and Patric Muir offered to donate land for schools, but their offers were rejected as there was no road to the school. In 1889, the West Coast Improvement Company sold a plot of land to the school district for $200 to build a school, donating the $425 additional value. The first real school built at Fourth (Twenty-fourth) and Broadway (Market) burned down, replaced by another Broadway school at the same location. By 1903, Ballard had a school superintendent, 58 teachers, and 3,498 children of school age.

In a book produced for the Portland Exposition in 1905, the fourth-grade class of the Eastside School wrote a history of Ballard, including a description of the first class. They reported that the first students occasionally saw bears on their way to school through what would have been recently logged-off woods.

Most of the early schools are gone, and even some of the more "modern" schools have been closed or used for different purposes. One of the difficulties in tracing the schools in Ballard is that several schools were renamed and repurposed in the same location. For example, the old Central School became Ballard High School, and then Washington Irving (elementary, K-8) school. Until the late 1920s, the usual progression of children in school was through eighth grade; after they graduated, they either went on to attend Ballard High School or entered the workforce. "Junior High" schools weren't a fixture until the opening of Alexander Hamilton in 1927 and James Monroe in 1931. In addition, several schools were designated as "Industrial" schools, meaning that they taught more practical vocational skills. By the mid-1910s, schools were so crowded that "portables" were set up to take care of the overflow.

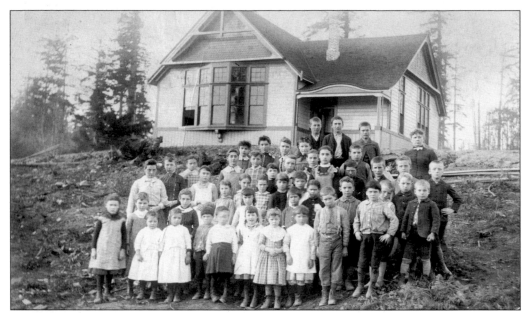

EARLY BALLARD SCHOOLHOUSE. The Ross School, which may be the earliest schoolhouse in Ballard, opened in Dr. Ross's house on Third and Forty-third NW in 1873. The other early Ballard school was operated in a house owned by the Bryggers in 1887, with 18 students attending. Gertie Marsh was "imployed [*sic*] to teach a term of school three months at $30 a month." In 1889, the applications of a Miss Kempster and A. Lyons (returning teachers) were rejected "in favor of home talent." Ross School proper was built in 1881, condemned as a fire hazard in 1929, and finally torn down in 1941. (Courtesy Seattle Public School District.)

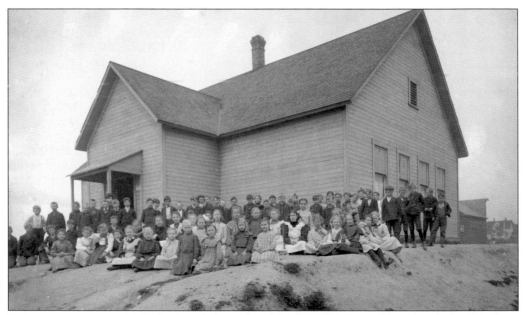

BROADWAY SCHOOL, 1903. Built at Twenty-fourth and Market Street (Broadway), the Broadway School was a three-room school that operated from 1889 until 1909. The building was eventually sold to Vasa Lodge, who in turn used it for years until it was razed for a gas station. (Courtesy SPSD.)

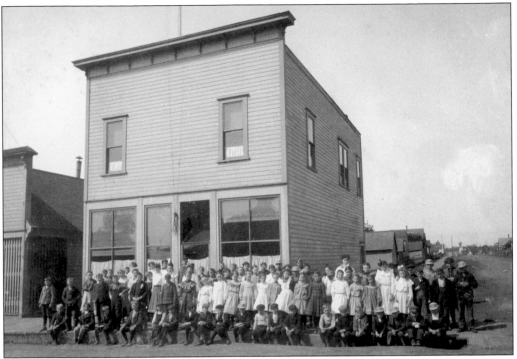

NORTH STREET SCHOOL. The North Street School opened about 1905 at the southwest corner of North (Sixty-fourth NW) and present-day Twenty-second. It was closed after Webster was established. (Courtesy SPSD.)

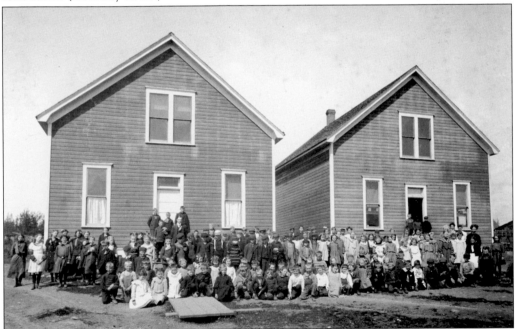

BAY VIEW SCHOOL. The original Bay View School was located on the current site of the Nordic Heritage Museum and included two portables facing Sixty-eighth, two more facing Sixty-ninth, and a principal's office to the west of the portables. (Courtesy SPSD.)

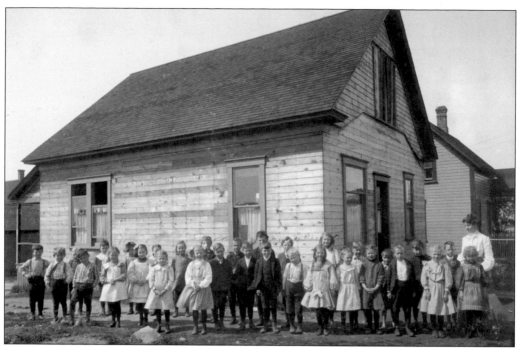

BAKER STREET SCHOOL. This image provides a rare view of a school that only operated for one year, from 1904 to 1905, at Baker and Fourth Avenue (Sixtieth NW and Seventh NW). (Courtesy SPSD.)

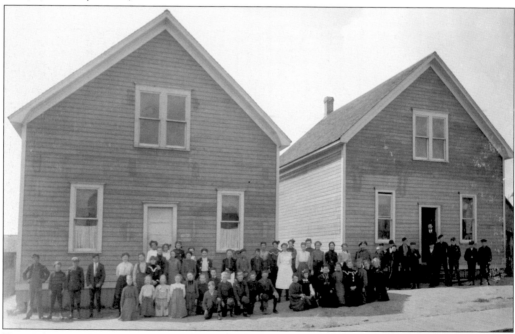

FERRY STREET SCHOOL. The Ferry Street School consisted of two portables on the west side of Ferry Street (Twenty-fifth), between what is now Sixty-seventh NW and Seventieth NW, as an annex to the Bay View School. After its run from 1904 to 1908, students were incorporated into the new Webster School. (Courtesy SPSD.)

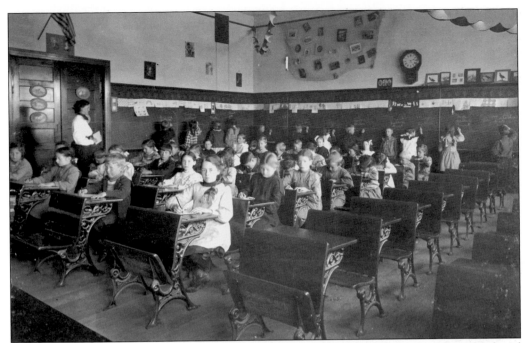

SALMON BAY SCHOOL. Constructed in 1901 at Twentieth Avenue between Sixty-third and Sixty-fourth NW, this building is the site of the current Boys and Girls Club and bears no connection to the current Salmon Bay School occupying the former James Monroe Junior High School. Salmon Bay operated until 1932. This class is identified as "Spelling, 2nd Grade, Salmon Bay." (Courtesy SPSD.)

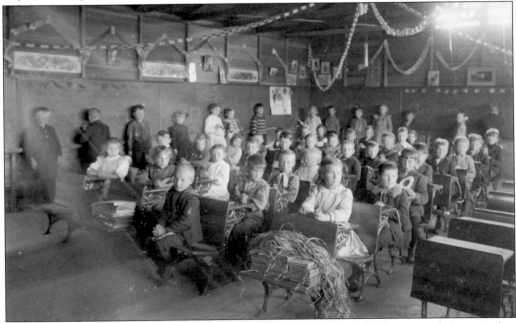

SALMON BAY SCHOOL INDUSTRIAL WORK. The pile of rope in the foreground suggests that the students were picking oakum, which is the unraveling of old ropes used to make planks on wooden ships watertight. (Courtesy SPSD.)

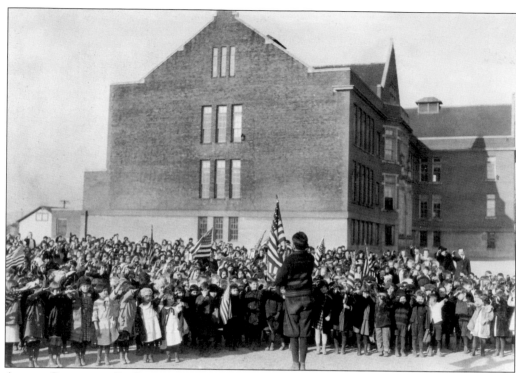

ADAMS CHILDREN. Built in 1909, Adams included the students of the nearby Cleek School, which had been located since 1903 at Twenty-second and Fifty-seventh Street, as well as pupils from Broadway School on Twenty-fourth. The Jacobean-style building had 500 students and 13 teachers in grades one through eight and was not named for any member of the illustrious Adams family in particular. The following exercise from Adams sums up an earlier, more innocent era in Ballard's school system: "For Adams Pupils: (1927) I am a citizen of Seattle, of Washington, and of the United States. It is my right and my duty to make an honest living and to be comfortable and happy. It is my privilege and my duty to help others to secure these benefits. I will work hard and play fair. I will be kind to all, especially to little children, to old people, to the unfortunate, and to animals. I will help make Seattle a clean, beautiful and law abiding city. These are the best services I can render to my city, my state and my country." (Courtesy SPSD.)

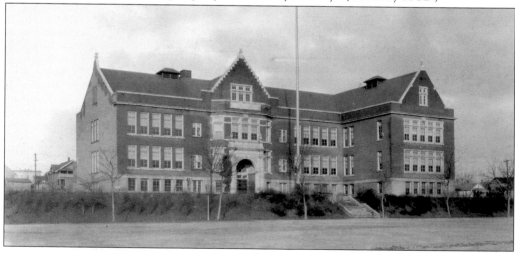

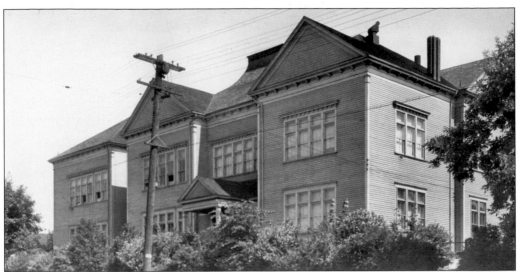

LEWIS BUILDING ANNEX AND EASTSIDE SCHOOL. The Eastside School (above) opened at Railroad Avenue and Holbrook (Fourteenth and Fifty-second) in 1902. The annex (below) operated from 1908 to 1910 in four rooms rented from Henry Lewis. In quite possibly the most confusing school naming sequence ever, the Eastside School was renamed Washington Irving in 1910 but closed in 1915. Students were transferred to the Central School, which was renamed Irving! Eastside/Irving became Ballard Special School in 1915, Robert Fulton School in 1929, and then a special needs school, industrial school, warehouse, and WPA offices. It was finally sold in 1948. Irving was colloquially known in Ballard as "the Peanut College" for years. (Courtesy SPSD.)

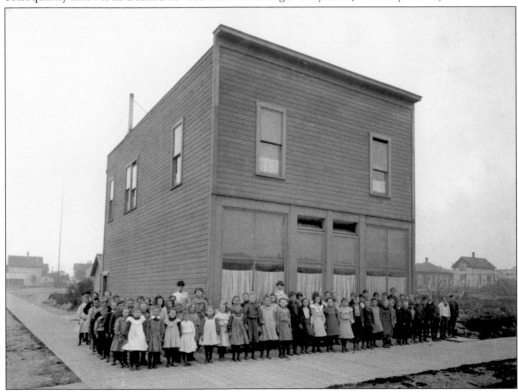

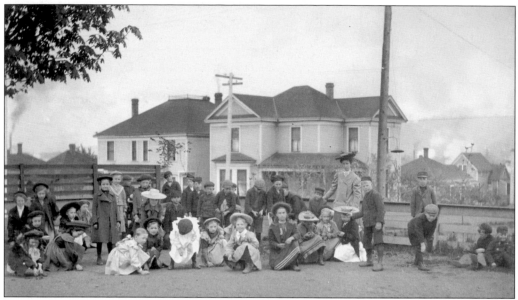

THE CENTRAL SCHOOL. This early view of the Central School was taken before September 7, 1909, when it was renamed Ballard High School. The original caption reads, "Picking flowers on the playground, 2nd grade, Central." The first principal was Professor Layhue, followed by Mr. Giles, Mr. Kendall, and Mr. Bennett. (Courtesy SPSD.)

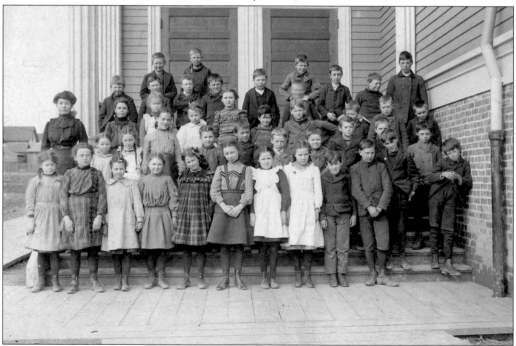

THE CENTRAL SCHOOL. The first real high school in Ballard, Central was built in 1891 at 5308 Tallman Avenue, on the site of a previous school that had burned down in 1889. Originally, it served first through ninth grades. After the new brick Ballard High School was completed, the Central School became Washington Irving Elementary from 1916 through 1940. It was eventually torn down and Ballard Hospital erected at the location. (Courtesy SPSD.)

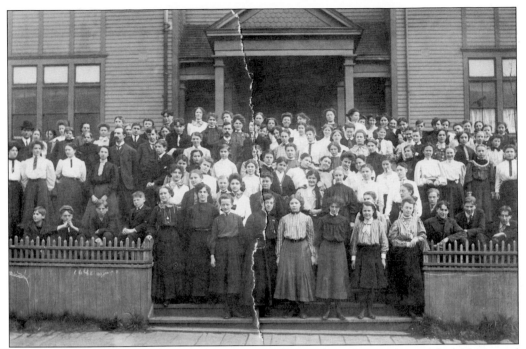

BALLARD HIGH SCHOOL CLASS. This photograph must have been taken at the old Central School on Tallman, as the new Ballard High School was a brick building. The names Central and Ballard were used interchangeably up to 1916, and they and Washington Irving all described at least two different buildings. The first class through 12th grade at Ballard High School (Central) was in 1901. (Courtesy SPSD.)

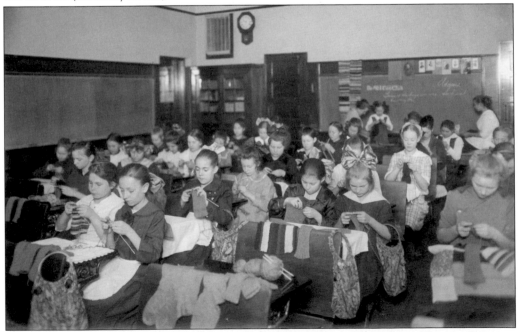

CENTRAL. Here students knit for soldiers during World War I. They also collected sphagnum moss, which was used in dressings for the wounded. (Courtesy SPSD.)

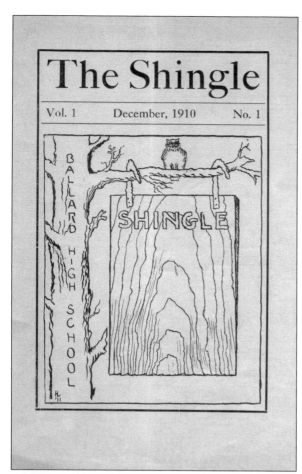

The Shingle

Vol. 1 December, 1910 No. 1

THE SHINGLE. The *Shingle* was first produced in 1910 but soon evolved into Ballard High School's annual. Current students may be perplexed over the name of their yearbook. Because Ballard was the Shingle Capital of the World, the *Shingle* stuck; this also explains the team name of Ballard Beavers. (Courtesy Clinton White.)

READING AT THE CENTRAL SCHOOL. Not only is Ballard High the oldest continuously operating high school in the city, but some of the staff had amazing longevity. A Mr. Fleming came to Central in 1908 and stayed 48 years as a teacher. The first graduates in 1904 were Eva Chambers, Mary Lyle, Victoria Bourgeois, and Anna Olsen. There had been 22 others in their graduating class, but economic necessity made it hard for children to even finish eighth grade. (Courtesy SPSD.)

REAR OF AUDITORIUM. Taken during the second decade of the 20th century, this photograph shows the auditorium at Central School. There was no gym; the old Broadway School on Twenty-fourth was used for that purpose. (Courtesy SPSD.)

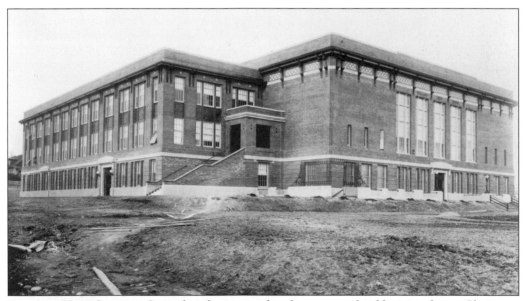

BALLARD HIGH SCHOOL. Central students moved to the present school location during Christmas vacation in 1915, and 300 students transferred from Lincoln. The building was remodeled in 1925, 1941, and 1959; demolished in 1997; and rebuilt in 1999 to accommodate 1,500 students. At the height of the baby boom, over 2,000 were enrolled. (Courtesy SPSD.)

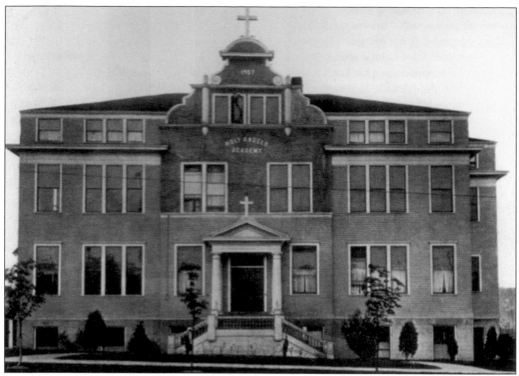

ST. ALPHONSUS AND HOLY ANGELS ACADEMY. Built at Fifteenth NW and Fifty-eighth Street NW, Holy Angels (above) opened in 1907 with 75 students; before the first term was over, it would include 200 students. The first high school student, Doria Hamel, graduated in 1908, and 14 eighth graders passed the state board exam. By 1923, both the high school and grade school were literally exploding with students, and the present St. Alphonsus School was constructed at a cost of $120,000, with the high school on the top floor and grade school on the bottom floors. (Courtesy St. Alphonsus.)

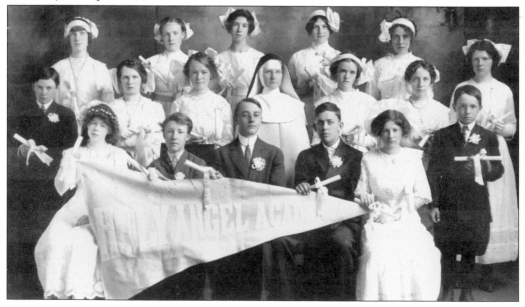

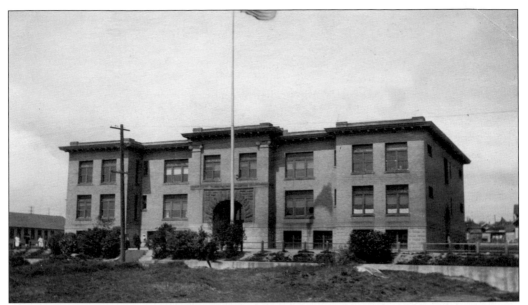

WEBSTER SCHOOL. The school was closed in 1979 and now lives on as the Nordic Heritage Museum. Originally called the Olympic School, it opened as Bay View in 1908 but was christened Webster two months later. (Courtesy Clinton White.)

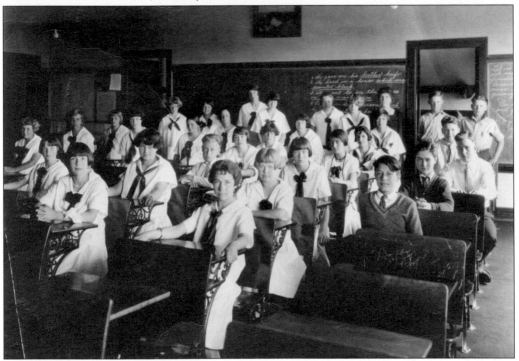

WEBSTER SCHOOL CLASSROOM. Judging by the hairstyles, this photograph was taken sometime in the early 1920s. Webster opened in 1908 to accommodate the growing enrollment of the Bay View and Ferry Street Schools and the exploding population of what was the Gilman Addition, now Sunset Hill. The school remained virtually unchanged when the author attended it in the 1960s. (Courtesy Bertha Davis.)

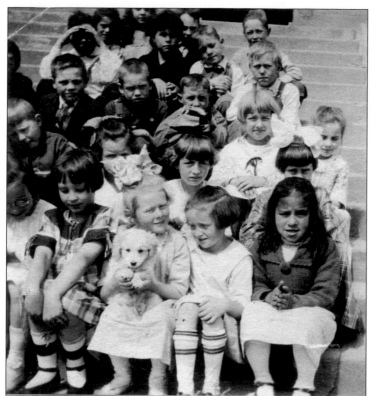

WEBSTER SCHOOL
SECOND-GRADE CLASS,
1919. In this charming
class portrait of Webster
students, one student
holds a puppy. (Courtesy
Bertha Davis.)

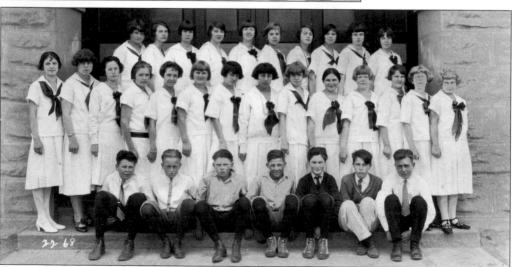

WEBSTER SCHOOL EIGHTH-GRADE GRADUATING CLASS, 1925. The last eighth-grade Webster
class would be held in 1931, when James Monroe opened. These students are named Genevieve
Anderson, Ruby Bakken, Ethel Brannon, Kathryn Bronnische, Maurine Bronnische, Marguerite
Carlson, Marion Church, Emma English, Ruth Fletcher, William Grandpre, Marguerite Hunt,
Merrill Knapp, Wendell Knutsen, Nina Larsen, Ella Mae Leque, Helen Maatheson, Videna Martin,
Gertrude Morrison, Mae Murray, Edith Nixon, Thelma Nygard, Norman Peterson, Charles
Richardson, Marion Schilling, Sidney Sims, Eleanor Sutcliffe, Beth Tanner, Ruth Thomson,
Norman West, and teacher Mabel Mueller. (Courtesy Bertha Davis.)

Eight

FRATERNAL
ORGANIZATIONS
AND CHURCHES

By the start of the 20th century, Ballard boasted 19 very active fraternal and social organizations, many of which still exist today. In a simpler time, social life revolved around dances and activities, picnics, ice-cream socials, and fund-raisers. In a time when medical insurance was nonexistent, fraternal organizations helped their members in times of need with medical costs, life insurance, burial fees, and widow and orphan assistance.

The Masons Occidental Lodge No. 72 in Ballard was chartered in 1891. The Masons still meet in the handsome brick building they constructed in 1924, located on the corner of Market Street NW and Twentieth Avenue. The Eagles Building, started in 1923, cost a whopping $425,000 and was described in the paper as "the most lavish on the West Coast." A plaque erected in 2007 on the Eagles' temporary quarters above the old *Ballard News Tribune* offices on Ballard Avenue erroneously awards those accolades to the wrong building.

Vasa Hope Hall stood between Market Street and Fifty-sixth Street west of Twenty-fourth, part of the Swedish Club (*Frihet*, meaning "freedom") formed in 1892. Dances were held several nights a week, as well as choir practice in Swedish, dinners, and outings to Vasa Park. The Vasa Lodge was one of a few organizations that did not form in order to provide benevolence or insurance benefits to its members. The Sons of Norway had a hall on Minor, and the Norwegian community has always been very active in Ballard, holding a parade every May 17 for 100 years. The American Legion Post is named for Lloyd Cochran, born in Ballard in 1894 and an athlete who graduated from Ballard High with honors in 1912. A graduate of the University of Washington Law School, he was killed in action at the Argonne in 1918.

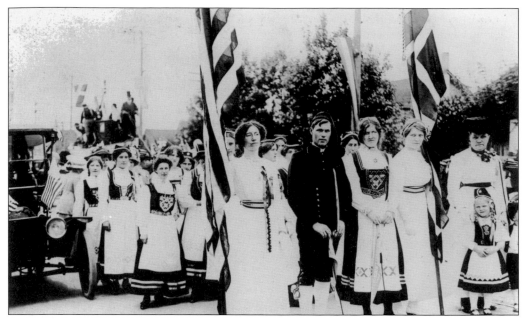

SYTTENDE MAI PARADE, 1913. For over 100 years, Ballard has had a parade on *Syttende Mai*, May 17, to celebrate the Norwegian Constitution. Then as today, Norwegians wore their *bunad*, or national costume, to show pride in their native land. Many Ballardites may be three or four generations removed from Scandinavian countries, but all still honor their heritage. In fact, Ballard boasts the last Norwegian newspaper in America. The Sons of Norway was formed on April 26, 1903, as the Leif Erikson Lodge. On October 19, 1905, Valkyrien Lodge, Daughters of Norway of the Pacific Coast, was established as a separate but not subordinate organization. Olga Linvog is the young lady in the middle. (Courtesy Nancy Ferkingstad.)

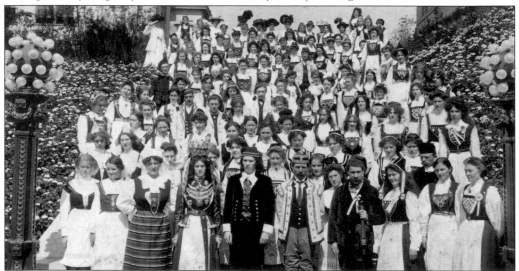

NORWAY DAY PARADE. Norwegian youth dressed in *bunad* pose on the steps of Meany Hall at the University of Washington on August 30, 1909, for the Alaska-Yukon-Pacific Exposition. The fourth and fifth people from the left in the first row are dressed as a bridal couple. Third from the right in the first row is Anne Knutsen Brynelsen. This particular photograph has been identified variously as Icelandic, Norwegian, and Finnish! (Courtesy University of Washington.)

94

CLARA BJORNSSON. While wearing an Icelandic costume, Clara Bjornsson holds her son Dwight. She has been elected *Fjallkona*, which loosely translates as "Maid of the Mountain," and in her lap is the Icelandic flag. Although not as numerous in Ballard as Norwegians or Swedes, Icelanders have always been a vital part of the community. (Courtesy Margo Bjornsson Highfill.)

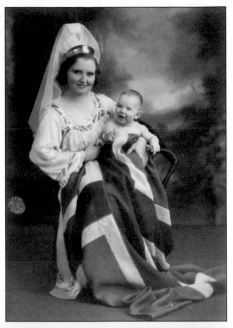

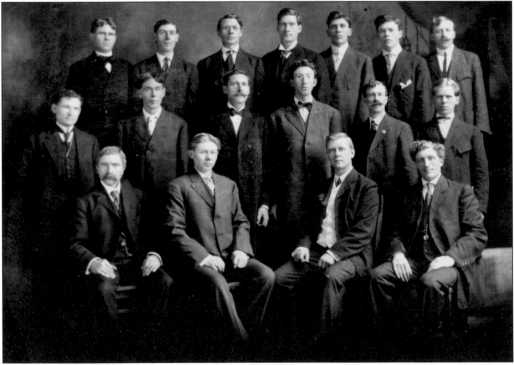

ICELANDIC MEN'S CHORUS, 1910. After using community halls for several years, in 1904 the Icelandic Improvement Association built a meeting hall of its own: Vestri Hall, located at 1540 West Sixty-fourth Street. In 1915, Vestri meetings began to be held in private homes because attendance was too low for the club to afford the cost of the hall. Financial support was shaky, and in 1919, pressed by property tax indebtedness, the association sold the property. The hall was razed in 1965. (Courtesy University of Washington.)

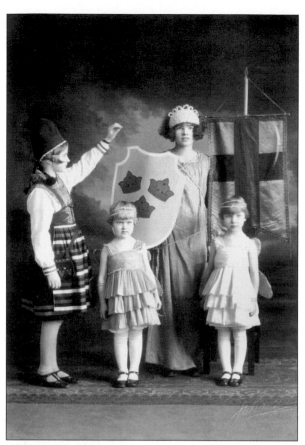

CHILDREN IN SWEDISH COSTUME. Children don Swedish national costumes for a studio portrait. The young blond girl at center left is Ruth Carlson. Notice the fairy wings on the girls' costumes. (Courtesy Dave Wolter.)

VASA. This photograph of a play was taken at the beginning of the 20th century at the Vasa Hall. There seems to be some kind of contest going on, as many of the young ladies in native dress have numbers pinned to their dresses. (Courtesy Dave Wolter.)

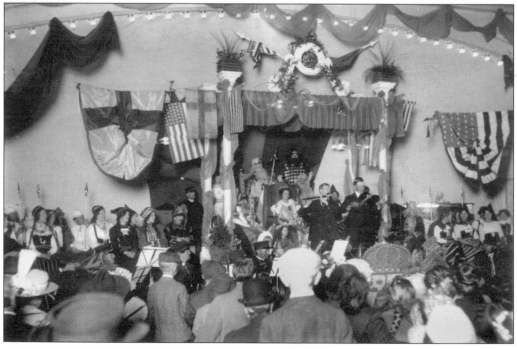

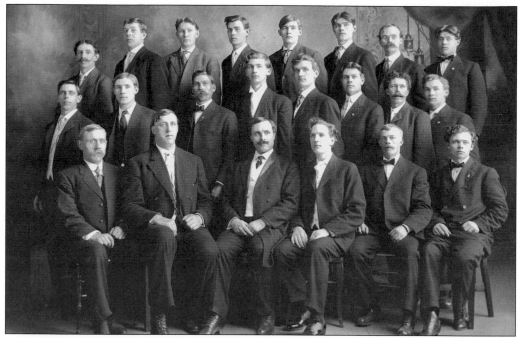

SWEDISH CHORUS *BRAGE* OF BALLARD. The Swedish Men's Chorus formed in Ballard in 1905. One of the functions of the Vasa Hope Lodge was to maintain a sense of Swedish heritage, language, and culture in a new land. This glee club was a vital link in keeping the Swedish language alive for young people. (Courtesy University of Washington.)

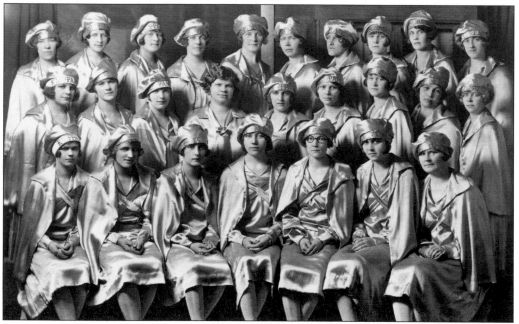

VASA DRILL TEAM. Young ladies from the Klippan Lodge, Vasa Order of America, are pictured in the 1920s. The Vasa Lodge still meets monthly at the Ballard VFW Hall, but most activities in the Swedish community occur at the Swedish Cultural Center on Dexter. (Courtesy University of Washington.)

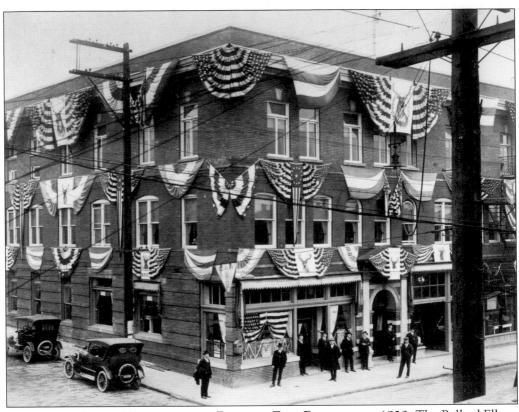

BALLARD ELKS BUILDING, C. 1920. The Ballard Elks once owned the beautiful Mathes Building on Ballard Avenue, which later became the Olympic Health Club. Constructed in 1903, it contains a basketball court that was once a grand ballroom. A third story was added to the original two-story structure in the 1920s, and it has at various times housed a secondhand store, the Dexter Horton Bank, a card room, a speakeasy, a hotel, the Old Home Tavern, and the first post office in Ballard. Here the Mathes Building is decked out with bunting and flags of the Elks for a Fourth of July celebration. (Courtesy Swedish Hospital.)

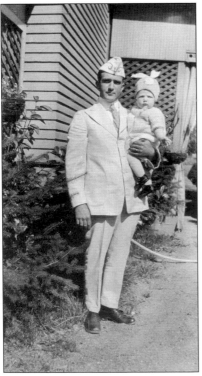

BALLARD ELKS, 1920. Jack Pheasant and his son Robert are seen on July 4, 1920, on the corner of Fifty-sixth Street and Twenty-second NW, where Washington Mutual Bank stands today. Jack is dressed in his Elks uniform, preparing for the parade. This photograph's inscription reads, "Bob is wearing his Elks hat too!" The year was momentous—it was when the group acquired the Mathes Block. Jack served as head of the dance committee then. (Courtesy Bob Pheasant.)

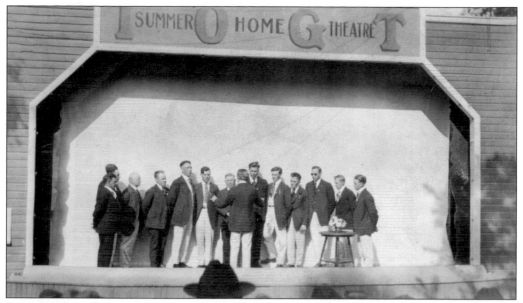

SUMMER HOME THEATER. The International Organization of Good Templars (IOGT) describes itself as "the largest international non-governmental organization working in the field of temperance." The group's base is in Sweden, a country that has had very strict alcohol policies and laws in the past. The IOGT are seen here at their Summer Home Theater putting on a skit, no doubt about the evils of drinking. (Courtesy Dave Wolter.)

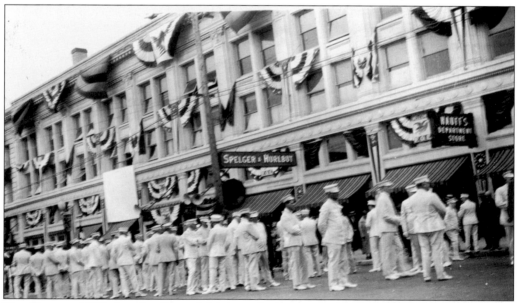

THE EAGLES, 1927. Another *Syttende Mai* parade progresses in front of the Eagles Building. The Ballard Aerie would be the second lodge in the country. At the time, the Eagles had over 1,600 members in Ballard. Stock certificates in the building were actually printed, but the Eagles could not support the costs, and the building eventually changed hands. (Courtesy Bob Pheasant.)

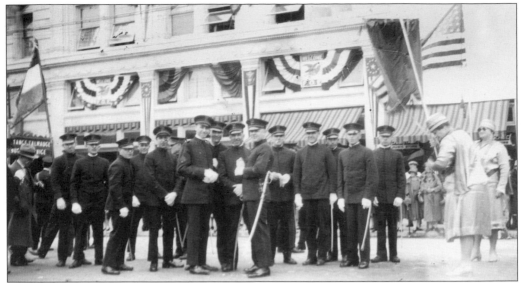

MARKET STREET, MAY 17, 1927. It is hard to determine what group these fellows belong to as Ballard had a plethora of fraternal organizations, including the Elks, Eagles, Lions, Kiwanis, Masons, Odd Fellows, Moose, and Rotary. Many of the societies meeting up until the late 1920s no longer exist in Ballard, or their numbers have dwindled. The Fraternal Brotherhood, the Maccabees, the Knights of Pythias, Danish Brotherhood, the Redmen, Ancient Order of United Workmen (Shilshole Branch), the Knights of the Moon, Brotherhood of American Yeomen Ballard Homestead No. 1125, Catholic Order of Foresters, Modern Woodmen of America, and the Woodmen of the World were some of the organizations represented. (Courtesy Bob Pheasant.)

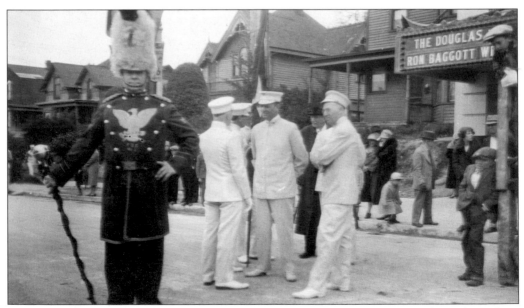

DRUM MAJOR, *SYTTENDE MAI,* 1927. This drum major must belong to the Eagles, judging from his regalia. The edge of the Bagdad Theatre appears to the right; the rest of Market Street was still residential at the time. (Courtesy Bob Pheasant.)

SCANDINAVIAN GRAND LODGE, IOGT. The Good Templars was a temperance organization quite active in Ballard for two reasons: Ballard had more saloons per linear foot on Ballard Avenue than anywhere else on the West Coast, and a preponderance of Swedes, the country where the group began. One of the chief complaints about Ballard Avenue was not prostitution, as popularly imagined, but in fact drinking, fighting, and gambling. This photograph was taken in 1908, one year after incorporation, when the City of Seattle would get involved in "cleaning up" Ballard Avenue. (Courtesy University of Washington.)

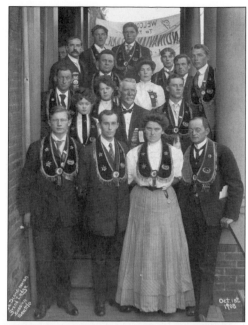

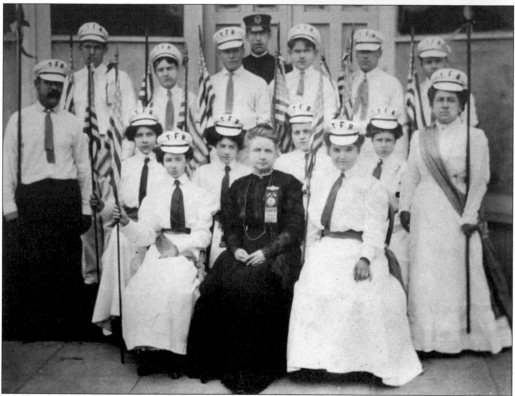

THE FRATERNAL BROTHERHOOD. One of a number of societies that no longer exist in Ballard, the Fraternal Brotherhood was a temperance movement organization that worked to ban the sale and consumption of alcohol. Here the group's drill team is dressed up for a Fourth of July parade. (Courtesy University of Washington.)

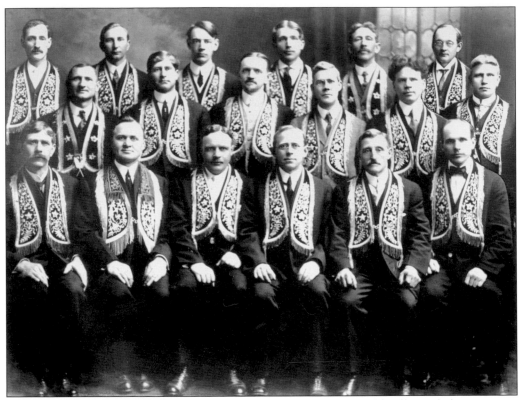

ODD FELLOWS. The Odd Fellows pledge is to uphold these four basic charges: visit the sick, comfort the widow, educate the orphan, and bury the dead. In a mill town and maritime center, there were plenty of illnesses, accidents, and sudden death, and life expectancy was around 45 years old. Woog's Hall, built by Ole Woog, can still be seen at 1706 Market Street, looking much as it did here in 1911. (Courtesy University of Washington.)

THE GRAND ARMY OF THE REPUBLIC. The Grand Army of the Republic (GAR) was a fraternal organization composed of Union veterans of the Civil War. Founded in 1866, the group called for May 30 to be designated a day of memorial for Union veterans; originally called Decoration Day, it evolved into our current Memorial Day. The GAR held annual encampments such as this one in Ballard in 1907. Apparently the pins were printed before annexation, making them rare finds. (Courtesy Clinton White.)

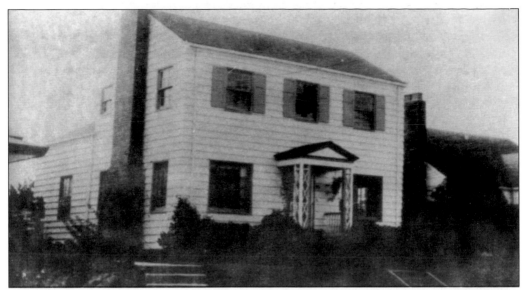

BALLARD PRESBYTERIAN CHURCH. The first Presbyterian church in Ballard was organized in the home of Janet Faulkner at Eighth and Market Street on November 8, 1889. Subscriptions for a building were solicited; among the contributors were notable Ballardites Capt. W. R. Ballard, R. T. Hawley, Dr. Walter Johnson, Frank Frazier, Judge Thomas Burke, John Leary, F. M. De Moss, and Charles McLaughlan. According to founder Rev. J. C. Canney, the church was the outgrowth of a Sunday school held in a sawmill boardinghouse. Amazingly enough, this house is still standing as of this date. (Courtesy Northminster Presbyterian.)

BALLARD FIRST PRESBYTERIAN CHURCH. The original incarnation of the Presbyterian church, seen here, was located at Seventeenth and Market Street. Note the planked streets on Market Street in this 1894 photograph. An expenditure of $60 was noted in 1895 for the purchase of a bell. After acquiring land on Sixty-fourth and Seventeenth and then moving into the Loyal Heights Congregational Church on Earl, the congregation eventually inhabited the Icelandic Liberal Church building on Twenty-fifth and Seventy-seventh NW in 1938. It was renamed Northminster Presbyterian. (Courtesy Northminster Presbyterian.)

ZION'S LUTHERAN CHURCH, BALLARD
MAY 19, 1907

SVENSKA MISSION CONFIRMATION CLASS. The Svenska Mission, also known as the Swedish Evangelical Church, started in 1884. The only people identified in this image are in the second row: G. Adolph Brattstrom (left), Rev. Henry Ek (fourth from the left), and George Lind (sixth from the left). (Courtesy University of Washington.)

ZION EVANGELICAL LUTHERAN CHURCH. This church was organized on April 27, 1894, as the first Lutheran congregation in Ballard, with Rev. I. J. Kvam as pastor. Originally meeting in a small storefront at Twentieth Avenue and Fifty-seventh Street, the congregation built the church with lumber donated by the mills; some of the women even helped shingle the roof. In 1896, the building at Fifty-sixth Street and Twentieth Avenue was begun. This church would join with the Bethlehem Lutheran Church to form what is now Ballard First Lutheran. (Courtesy Ballard First Lutheran.)

BETHEL CHURCH. The Bethel Church was mainly composed of the Swedes and Swedish Finns of Ballard. (Courtesy Paul Norland.)

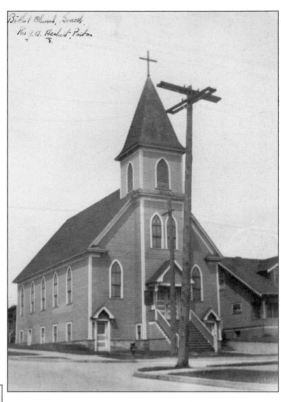

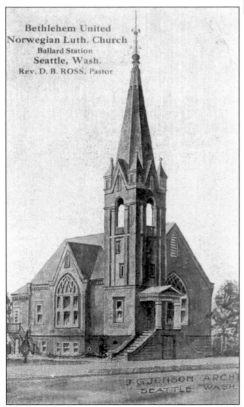

BETHLEHEM UNITED NORWEGIAN LUTHERAN CHURCH. Two congregations merged in 1917 to form Ballard First Lutheran: Zion Evangelical Lutheran Church (Fifty-sixth Street) and Bethlehem Lutheran (Twenty-second and Fifty-seventh Street). Built in 1930 to replace the Bethlehem Church building, Ballard First Lutheran was one of the largest in the city and services were provided in Norwegian. In 1929, Pastor O. Haavik started the tradition of the Blessing of the Fleet, which continues today. (Courtesy Clinton White.)

105

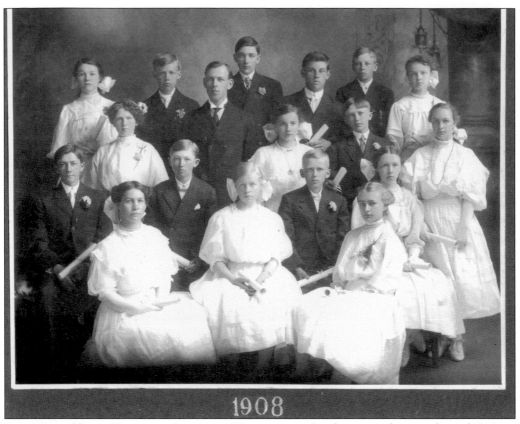

1908

BETHLEHEM NORSK EVANGELIC LUTHENSK KIRKE, 1908. Confirmation class members of 1908 are identified as Lillie Sigfrieda Albertson, Hilda Anderson, Jennie Otila Anderson, Violet Blomsness, Bertha Brekke, Clarence Haaland, Agnes Hagen, William A. Hansen, Inga Hoffield, Leo O. Larsen, Berntine Olson, Sidor Ingvald Olson, John E. Pederson, Carl Johan Rasmussen, Claud Riese, Marvin Severson, Halvor Strandrud, and Inga Warvik. (Courtesy Ballard First Lutheran.)

ST. ALPHONSUS. The first church was a little wooden building on a 50-by-100-foot lot. The parish began in 1891 as a mission staffed by the Redemptor Priests from Sacred Heart. Father Achtergael came from Chehalis in 1901 to become pastor of St. Alphonsus parish. (Courtesy St. Alphonsus.)

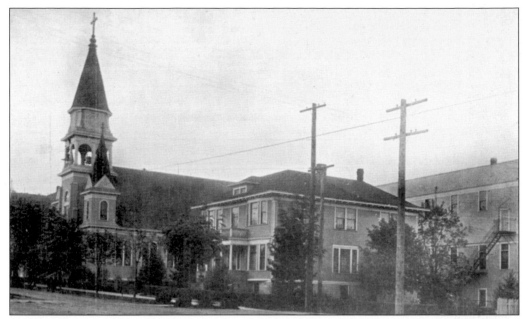

ST. ALPHONSUS. The second, larger church occupied a 200-by-350-foot lot that included a residence and a parish hall as well. The congregation raised $40,000 to build a three-story frame building across the street from the church to house a convent, boarding day school for primary and secondary students, and a novitiate. (Courtesy St. Alphonsus.)

ST. ALPHONSUS CHURCH CHOIR. One cannot help but admire these pre–World War I era hats! Pictured here from left to right are the following: (first row) J. Weeks, Mrs. G. G. Schram, Mrs. L. Campbell, E. Campbell, Mrs. A. Fitzhenry, H. Hefferon, and A. Bronkall; (second row) R. Fleury, B. Campbell, Mrs. J. M. Young, Mrs. H. H. Shewbridge, M. Hefferon, I. McGourty, and L. Campbell. (Courtesy St. Alphonsus.)

FR. GUSTAV ACHTERGAEL. Pastor of the St. Alphonsus parish, Fr. Gustav Achtergael was educated in Belgium and ordained by Bishop Brondel of Oregon in 1890. (Courtesy St. Alphonsus.)

MOTHER GUILELMA, WITH MRS. J. STAFFORD. Mother Guilelma (left) and her mother, Mrs. J. Stafford, stand alongside Monsignor Franklin's automobile. As superior of the academy, Guilelma insisted on higher education for all of the teaching sisters, and in 1916, the academy was fully accredited by the University of Washington. More vocations to the Dominican sisters of the Congregation of the Holy Cross would come from Ballard than any other parish in the Northwest. (Courtesy St. Alphonsus.)

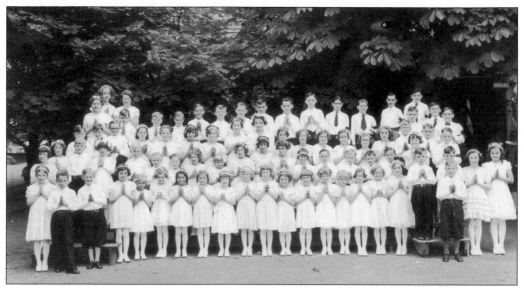

ST. ALPHONSUS CONFIRMATION CLASS. This class portrait, taken in the late 1920s, shows how large the Ballard congregation was at one time. Note the small boys in knickers. (Courtesy St. Alphonsus.)

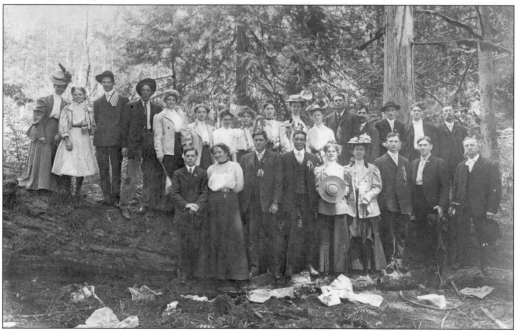

METHODIST CHURCH PICNIC. The first church of record was the Methodist Union, whose Sunday school operated out of a tent until a structure could be built. In 1910, the church stood at Third and State Street (Fifty-sixth) and is now located at Twenty-second and Fifty-sixth Street. Seen from left to right are the following: (first row) Vernon Armstrong, Mattie Jorkson, ? Gaines, ? King, Ethel Armstrong, Kate Chandelier, Bill Smith, Leonard Welsh, and ? Armstrong; (second row) Bella Hopkins, Martha Armstrong, George Strandberg, Frank Rathbon, Hattie Sutherland, Hazel Wilcox, Winnie Wilcox, Minne Armstrong, Iris Lewis, Belle Hopkins, Gertrud Armstrong, ? Gaines, Bob Hopkins, Paul Mackie, and ? Lewis. (Courtesy University of Washington.)

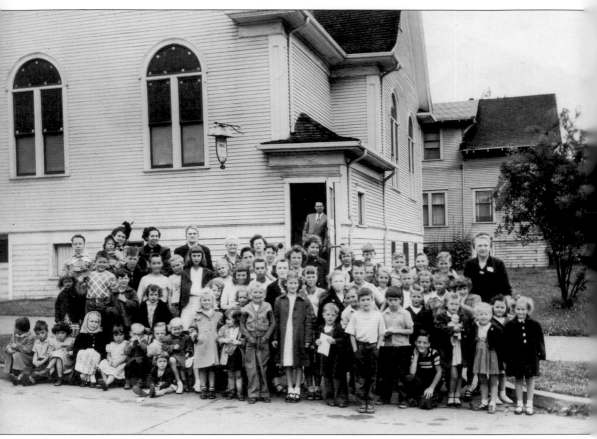

BALLARD GOSPEL CHURCH. This charming Sunday school photograph of the Ballard Gospel Tabernacle Church, at the southeast corner of West Sixty-first Street and Twenty-second NW, was taken by the Torvik Studio. Lutherans were not the only denomination in Ballard; virtually every religious group was represented. (Courtesy author's collection.)

Nine

FROM PIGSTIES TO PARADES, AND FROM CRADLE TO GRAVE

One of the most definitive themes of Ballard's history has always been its unique sense of cohesiveness, cooperation, and collaboration. As a community isolated geographically from the rest of Seattle, many Ballardites were connected in some way to one another—through kinship, culture, work, or church.

Many residents built their own houses with the help of their neighbors. Originally, houses were heated by wood stoves, then sawdust furnaces, because of the plentiful and cheap source of fuel from the mills. Many homes in Ballard were constructed from kits (precut lumber and plans from mills), which included blueprints and all the necessary framing, roofing, cabinets, windows, doors, paint, flour bins, and ironing boards—everything except lath and plaster.

Community life in Ballard centered around schools, churches, and fraternal and cultural organizations. Dances were held almost every night of the week at one of many halls on Market Street and Ballard Avenue, and children were almost always welcome. Amateur theatrics were a popular source of entertainment, as were the many movie theaters that sprang up in Ballard. For children growing up in the city in the late 1800s until the Depression, Ballard offered a variety of free entertainment in the form of vacant lots and woods in which to play. Ballard Beach, North Beach, and Golden Gardens provided endless amusement in the summer months, and the local rink, Green Lake, and Bitter Lake allowed for ice-skating in the winter. All the land above Eighty-fifth Street (the city limit) was wooded until the Olympic Golf Course (now Olympic Manor) was built, and there were riding stables on Holman Road where QFC now stands.

During Prohibition, many former saloons turned into ice-cream parlors and soda shops overnight to try and stay afloat. Drugstores like the Owl and Lafferty's in the Eagles Building had soda fountains, as did George Jacobsen on Shilshole across from the shipyard.

GOLDEN GARDENS. Henry Treat named Golden Gardens and Loyal Heights after his daughters, Golden and Loyal. These bathing beauties are well protected against the sun in their early-1900s bathing costumes. Until the 1930s, when Seaview Avenue was graded to Golden Gardens, the only access was by a flight of stairs at Eighty-fifth Street, a long, circuitous drive down a steep gravel road. (Courtesy MOHAI.)

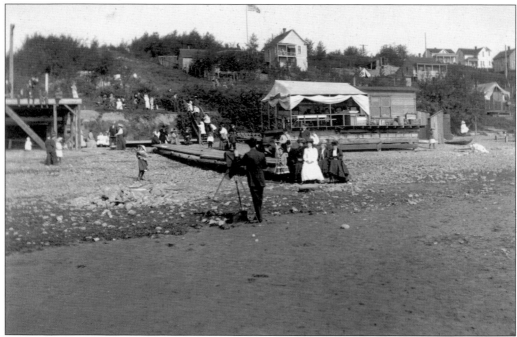

BALLARD BEACH. Carl Moen took this photograph of swimmers at Ballard Beach in 1910. The beach was located north of Ray's Boathouse, where Sunset West now stands. (Courtesy MOHAI.)

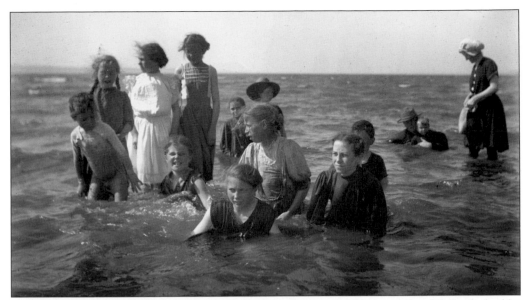

SWIMMERS AT BALLARD BEACH, C. 1913. The swimmers would be considered fully clothed by today's standards. Ballard Beach has been completely covered with restaurants and condominiums, though a small beach access exists on Shilshole between two buildings. One could still swim at Ballard Beach until the 1960s. (Courtesy MOHAI.)

SALMON BAY PARK. In 1890, Ballardites cleared brush and trees on a 2.8-acre tract of land deeded by Elan Denton between Sloop, Canoe, and Brig Streets (Seventieth NW) to create Salmon Bay Park, designed by the famous Olmsted brothers. At the time, the city limits of Ballard were at Sixty-fifth Street NW, and everything above that line was either rural or stands of timber. Ole Heggem, who grew up in the neighborhood, remembered seeing Native American encampments at the park in the summers before 1920. A man sits in the background in a bowler hat amidst flower gardens that sadly do not exist today. (Courtesy Bob Pheasant.)

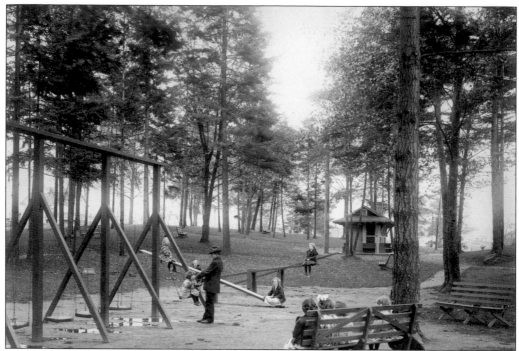

SALMON BAY PARK SWING SETS. Taken in 1910, this view shows the timber-framed swing sets and seesaw originally in the park, as well as the restroom, which was designed by Seattle architects Sauders and Lawton. The park's earliest incarnation also included a bandstand and dance pavilion and was sometimes called "Cow Park" because Ballardites grazed their livestock there. (Courtesy Seattle Municipal Archives.)

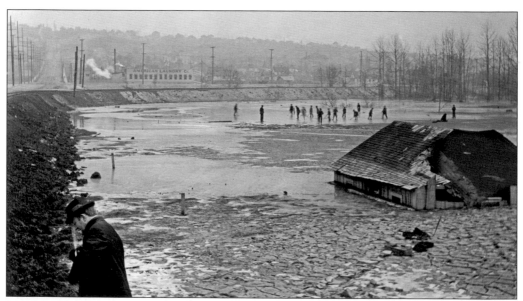

HOCKEY. Children play hockey at Eleventh and Forty-fifth Street on December 30, 1915. Ice-skating was a popular activity in Ballard; enthusiasts took the streetcar to Green Lake or Bitter Lake. The Ice Arena, a popular venue later, is now used by DanTrawl. (Courtesy Seattle Municipal Archives.)

TENNIS. Ethel Preston plays tennis at Ross School about 1910. The school is long gone, but the playground remains. (Courtesy Bob Pheasant.)

OLYMPIC GOLF COURSE. For many years, the city limits of Ballard, and indeed Seattle, were at Eighty-fifth Street NW. The Olympic Golf and Country Club, seen here in 1925, was situated at the city limits in what would become the Olympic Manor in 1950. Interestingly enough, the inventor of the Ping Golf Club, Karsten Solheim, grew up in Ballard; his father was a shoemaker on the northwest corner of Sixty-fifth Street and Twenty-fourth Avenue. (Courtesy MOHAI.)

MODERN DANCE. Girls at the Adams Fieldhouse participate in a dance, considered a viable alternative to team sports for exercise. Sports were not limited to the male gender, and one of the first Ballard women's basketball teams became the city champions with the unfortunate name of the Jim Crows. (Courtesy Seattle Municipal Archives.)

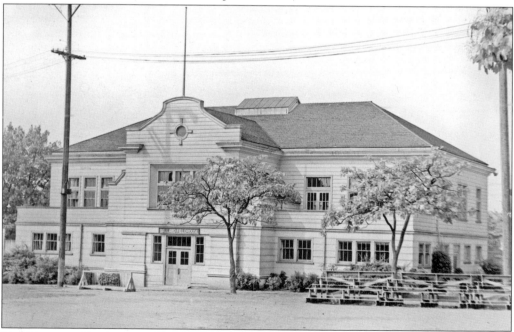

THE BALLARD FIELDHOUSE. The fieldhouse at the Adams School was one of the biggest centers of recreation for organized sports since schools did not have gymnasiums. When the new Ballard High School was built on Fifteenth NW, a gymnasium was included, complete with an indoor running track that was accessed by an iron circular staircase. (Courtesy Seattle Municipal Archives.)

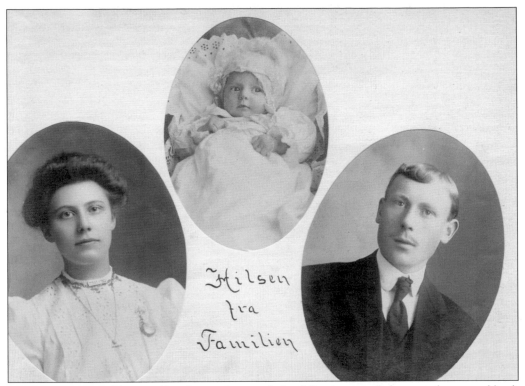

CHRISTOFFERSSON FAMILY. Family members took the following set of photographs to send back to relatives in Norway to proudly show off their new Ballard home in 1904. This image bears the inscription "Greetings from the family." Laura and Chris Christoffersson would have only one child before Chris died in the influenza epidemic in 1917. (Courtesy Margaret Anderson.)

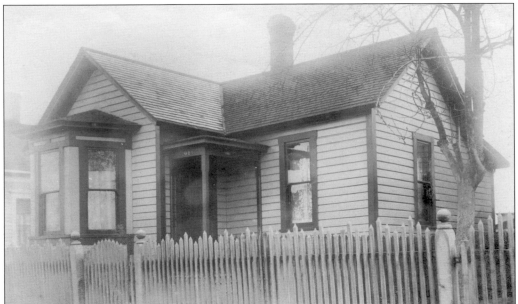

HOUSE. *Huset sett fra Saden* means "the house seen from the side." The Christoffersson home stood at 2049 West Fifty-eighth Street. (Courtesy Margaret Anderson.)

KJOKKEN. The Christofferssons' kitchen featured an elaborate cast-iron stove. (Courtesy Margaret Anderson.)

STUE. In the living room, a guitar sits in the corner and a portrait of a royal personage hangs on the wall. (Courtesy Margaret Anderson.)

SOVEVAERELSE. *Sovevaerelse*, the bedroom, literally translates as "the sleeping room." The couple's only child, Lillian, was born here in 1910. (Courtesy Margaret Anderson.)

SPISESTUE. Notice the sewing machine in the background of this dining room image. Most Ballard women were proficient seamstresses by necessity, though dressmakers abounded on Ballard Avenue. (Courtesy Margaret Anderson.)

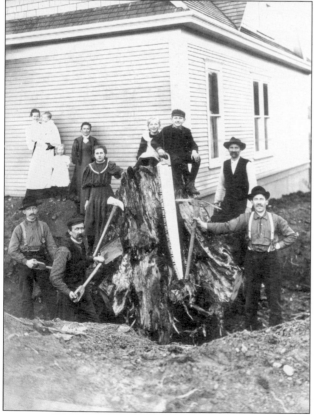

TENT LIVING. It was not unusual for people to live in tents while they built their houses in Ballard. Ingvald Heggem and Marit Westad were married on July 1, 1912, and began construction of a large residence at 7015 Twenty-third Avenue NW with the help of friends. They lived in a tent until it was completed. (Courtesy Signe Davis.)

HOUSE CONSTRUCTION. Ingvald Heggem and his friends Anton Anderson and Ole Roebeck built this house together around 1912. Timber was so plentiful that if a plank had a knot in it, the builder would simply burn the wood instead of using it. (Courtesy Signe Davis.)

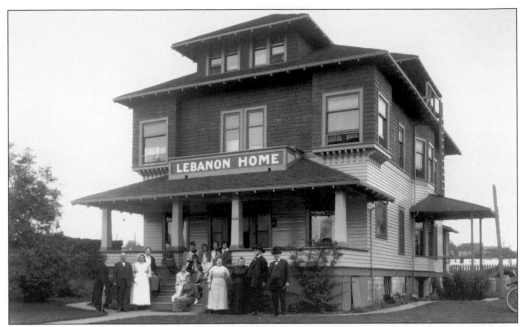

THE LEBANON HOME. The Lebanon Rescue Home, an orphanage and home for unwed and abandoned women, was located at 1110 Sixty-fifth Street NW. Libbie Beach Brown served as superintendent, and she and her husband, Rev. H. D. Brown, started the Children's Home Society of Washington. Many Ballard women were active in the Mother Goose Guild of the Children's Home Society from the 1960s through the 1990s. (Courtesy MOHAI.)

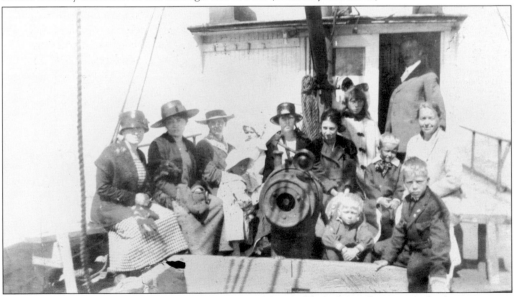

FAMILY OUTING BY SHIP. Ingvald Heggem and his extended family are pictured en route to Bainbridge from Ballard on his yacht *Viking* about 1918. A perk of living in a maritime community was going out on a relative's boat to fish, camp, or just motor around. Taking the Ballard-Suquamish ferry to go camping was a highlight of the summer, and rowboats were available for rent at the Ballard Boathouse and Reed's Boathouse, to name a few of the dozen near where Ray's Boathouse is today. (Courtesy Heggem family.)

RURAL BALLARD. The city was largely rural outside of the downtown of Ballard Avenue and later Market Street. Homeowners kept chickens and pigs and the occasional cow. Groves of nut trees and fruit orchards grew in Ballard until the 1970s, and one still occasionally stumbles onto an old barn down an alley. This photograph of Margie Conover and her dog Brownie was taken at her family home on Eighty-fifth Street. Just to the right, one can see the pigsty with the farm buildings in the background. Margie remembers turning a vacant lot into the Hinky-Dink Circus and charging the neighbors admission. (Courtesy Margie Nelson Conover.)

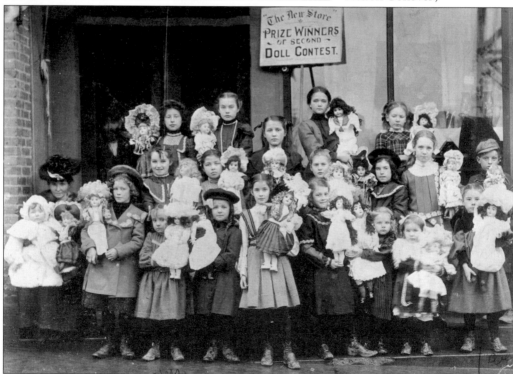

DOLL CONTEST. This image from the New Store's second doll contest in 1906 reveals an interesting collection of dolls, and one of the contestants seems to have provided a living baby. Contestants include Vera Pells, Lucille Fleuery, Dorothy Vernon, Emily Cooper, Grace Hawley, Margaret Sheppe, and Lucy Pyle. (Courtesy Swedish Hospital.)

BUDDING CONSTRUCTION WORKERS. In 1929, the owner of the S. H. Christianson Construction Company snapped this charming photograph of his three children. Robert James Christianson (left), Herman Sigurd Christianson (center), and Lillian Christianson help break ground for their new home at 6822 Thirty-fourth Avenue NW. The two boys would grow up to form their own construction company. The author's childhood home is visible in the background, and the house across the street is still standing as well. (Courtesy Mark Christenson.)

ROBERT PHEASANT, 1919. This view of Twenty-second and Fifty-sixth Street clearly shows that Twenty-second was entirely residential, with the exception of a few churches in the neighborhood. (Courtesy author's collection.)

GOAT CART. Photographers would travel around Ballard with a goat cart and take children's portraits, not unlike the process of having one's photograph taken with Santa at a department store today. Earl Linvog is pictured here at Sixty-first and Thirty-sixth NW. (Courtesy Nancy Linvog.)

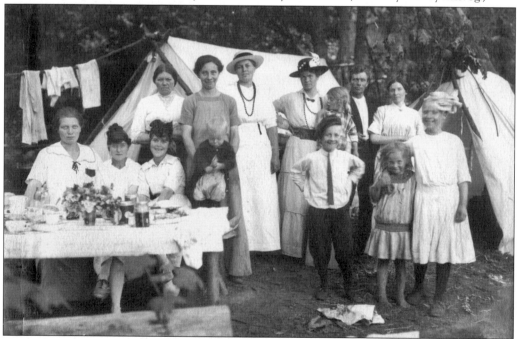

CAMPING. The Linvogs probably took their fishing boat to go camping, but many Ballardites camped at North Beach or at Golden Gardens. One of the most popular trips was to take the Ballard-Suquamish ferry to Suquamish. (The ferry dock is near where Ray's Boathouse now stands.) Note the china cups on the table, and consider how difficult it must have been to keep all of those white dresses clean while camping. (Courtesy Nancy Linvog.)

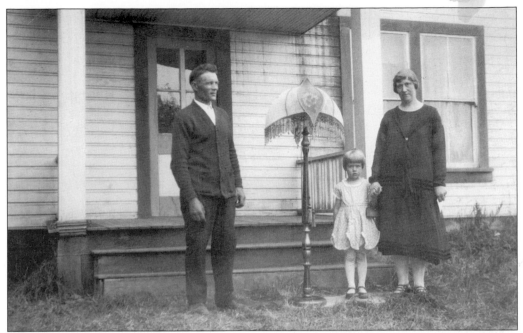

THE NEW LAMP. Carl Eric, Lavinia, and Ruth Carlson, who lived on Fourteenth Avenue NW between Sixtieth and Sixty-first, proudly display their very first electric light. Gaslights or kerosene lanterns were the light fixtures available in early Ballard; electric lights came in after Thomas Edison designed the successful incandescent lamp around 1879, but were still quite expensive. The lamp, in its original condition, is still owned by the family. (Courtesy Dave Wolter.)

BALLARD ABOVE MARKET AND TWENTY-SECOND, C. 1923. Robert Pheasant rides his tricycle on the sidewalk at Twenty-second and Fifty-sixth Street. The Ballard Building had yet to be built. Note the houses in the background while looking up Twenty-second. The site of the white house would become the National Bank of Commerce, then People's Bank, and finally the new Ballard Library. (Courtesy Bob Pheasant.)

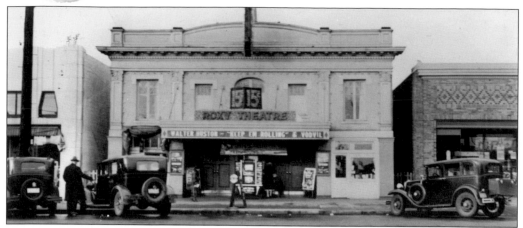

BALLARD THEATERS. Originally the Majestic, this theater had become the longest continuously running theater west of the Mississippi by 1998. Built in 1915 and remodeled in 1922, the Majestic featured a $25,000 Robert Morton theater organ. Renamed the Roxy and then the Bay after World War II, the structure was demolished and rebuilt by Ken Alhadeff, becoming the Majestic Bay. Other Ballard theaters included the Crystal in the Junction Building, the Bat on the corner of Sixty-third and Fourteenth Avenue NW, the Empress on the corner of Market Street and Tallman Avenue, the Bagdad on Market Street in the Eagles Building, the Woodland on Sixty-fifth Street and Sixth NW, and the Ballard near the corner of Ballard Avenue and Ione Street, which had a potbellied stove next to the stage and a nickelodeon playing outside.

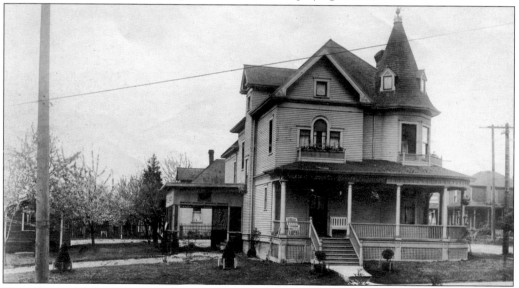

THE "CASTLE." In 1913, Jack Pheasant bought a business from Graham and Engeman and, in 1914, brought in Olaf Wiggen as a partner in his undertaking business at 5432 Ballard Avenue. The firm then moved to this Victorian Building at Twenty-second and Fifty-sixth Street, the current site of Washington Mutual. The living quarters were on the second and third floors, and the Ballard telephone exchange was located in the tower on the third floor. In 1925, Pheasant-Wiggen Mortuary bought the three-story brick building on the corner of Twenty-second and Market Street, which included apartments on the second and third floors. The garage for the ambulance was where a shoe repair shop stands now, and the apartments are almost completely unchanged from the 1920s. (Courtesy Bob Pheasant.)

CROWN HILL CEMETERY. In 1903, a group of Ballard businessmen led by Mayor Andrew Mackie bought and platted a 10-acre cemetery right outside the city limits of Ballard above Eighty-fifth Street, and the space was dedicated on June 10, 1903. Three generations of the Rothus family ran the cemetery for close to 100 years. It was a common practice to photograph funerals, with the images sent to family members in other countries. Crown Hill Cemetery still allows upright markers, and plots are available. Note the cars in the background. (Courtesy Laura McLeod.)

CITY LIMITS. Maud Reid Adams (right) stands at the city limits of Seattle at Eighty-fifth Street and Thirty-second, at the entrance to Golden Gardens and the end of the Loyal Heights streetcar line. The author has inserted herself in the image, complete with vintage hat, exactly in the same spot on Eighty-fifth. (Courtesy Joyce Bailey.)

DISCOVER THOUSANDS OF LOCAL HISTORY BOOKS FEATURING MILLIONS OF VINTAGE IMAGES

Arcadia Publishing, the leading local history publisher in the United States, is committed to making history accessible and meaningful through publishing books that celebrate and preserve the heritage of America's people and places.

Find more books like this at
www.arcadiapublishing.com

Search for your hometown history, your old stomping grounds, and even your favorite sports team.

Consistent with our mission to preserve history on a local level, this book was printed in South Carolina on American-made paper and manufactured entirely in the United States. Products carrying the accredited Forest Stewardship Council (FSC) label are printed on 100 percent FSC-certified paper.